The corridor ran like a lonely, dismal, fluorescent-lit stream

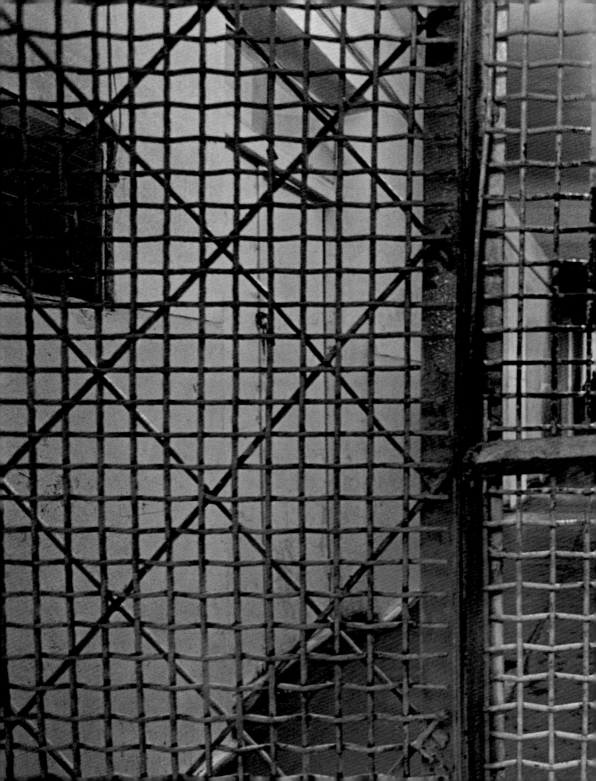

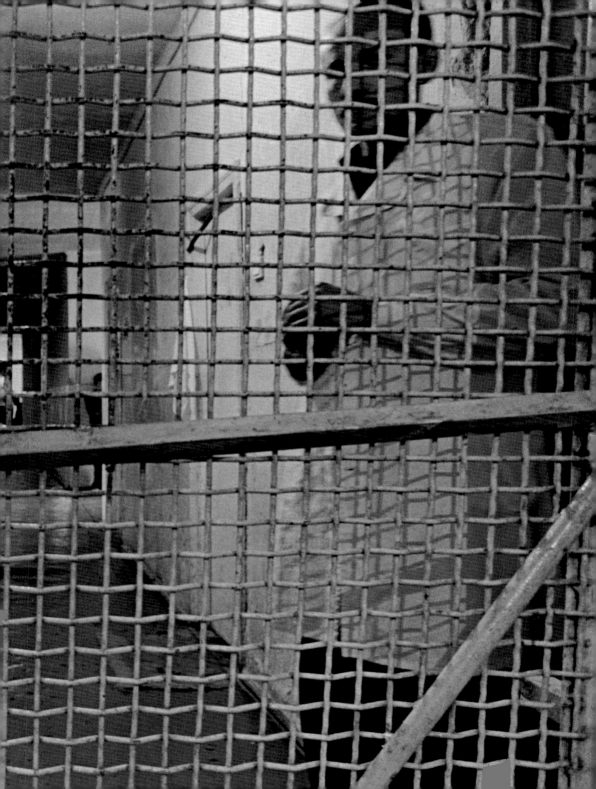

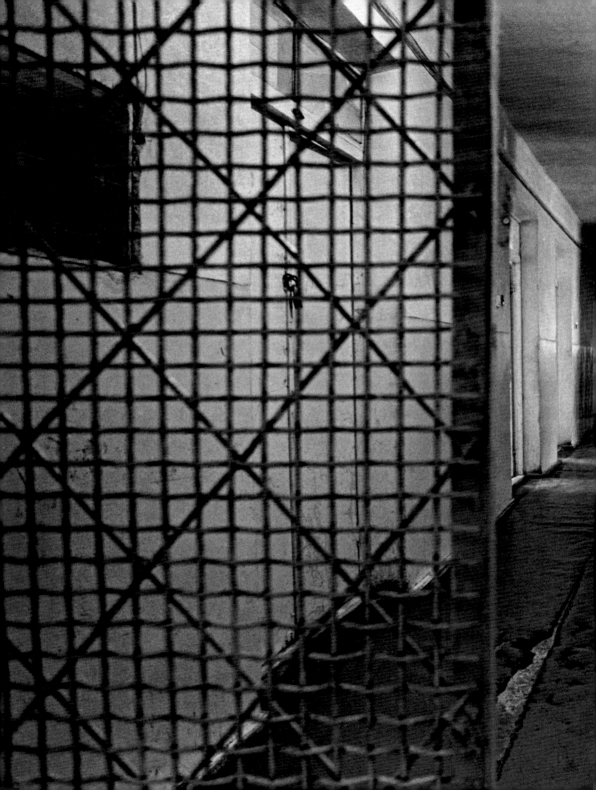

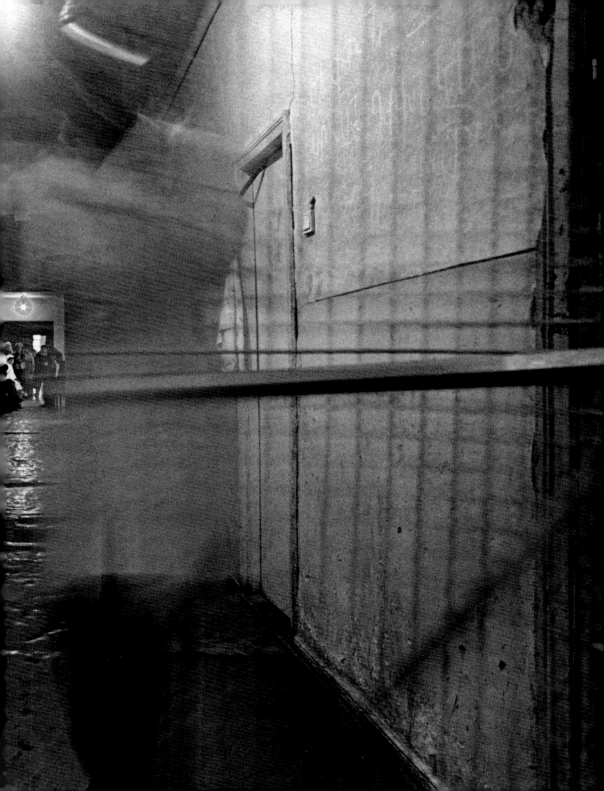

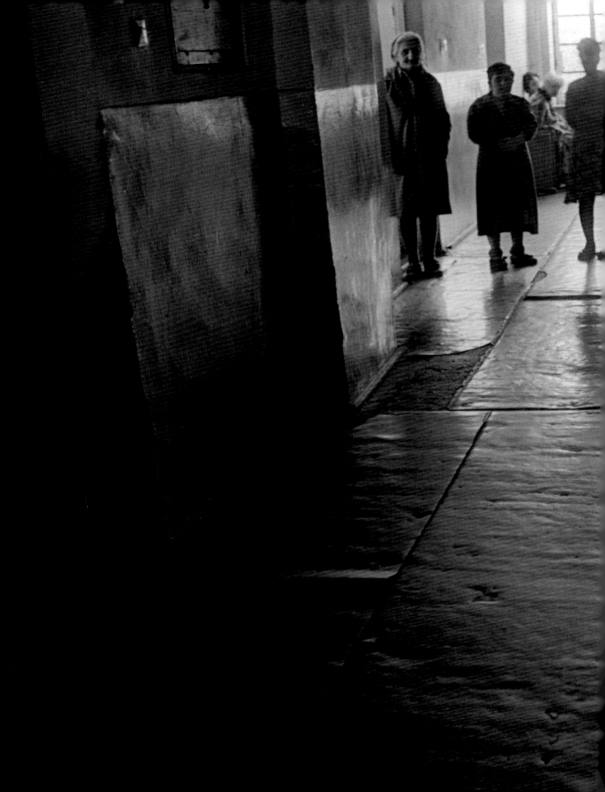

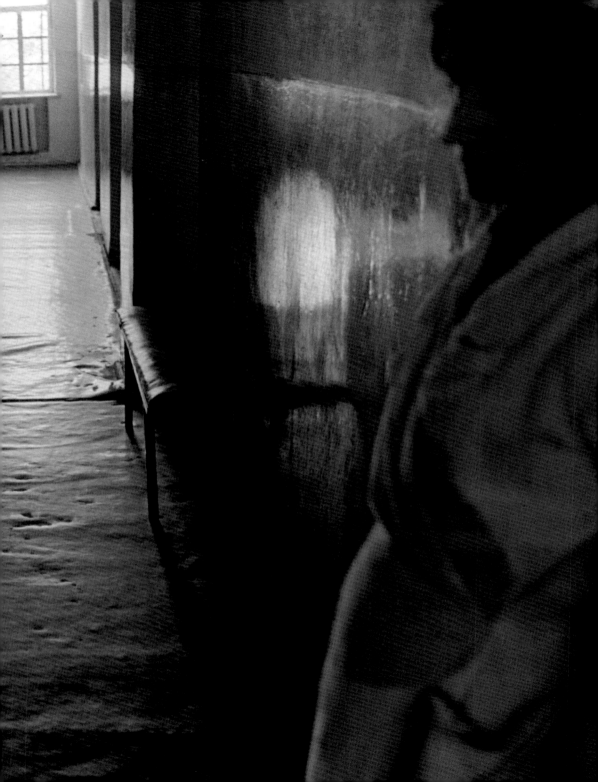

through the institution, then opened up into a vast, garage-like space. All that separated

University of Texas Press

A Procession of Them

Eugene Richards

ne now from the patients was a low wall.

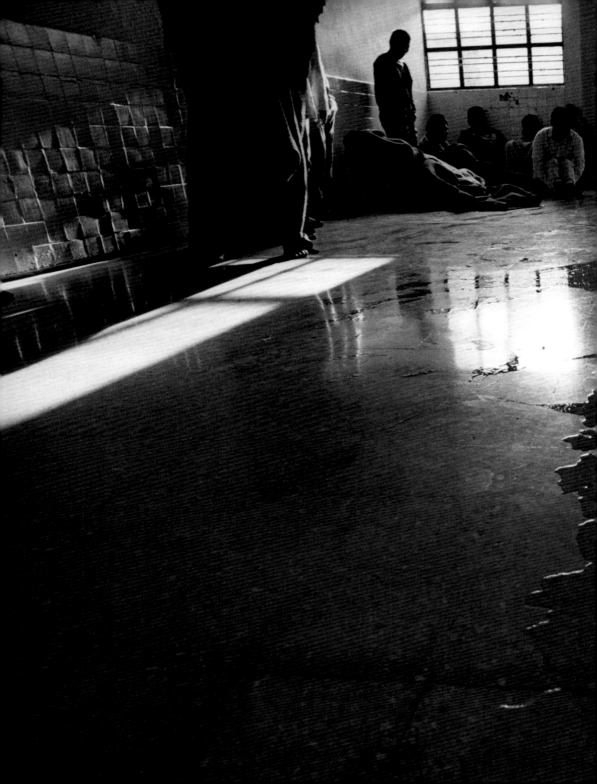

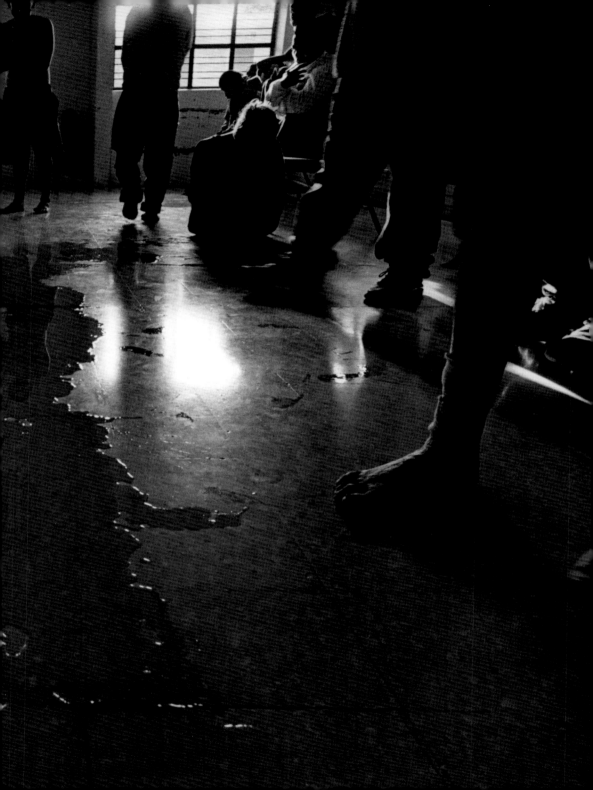

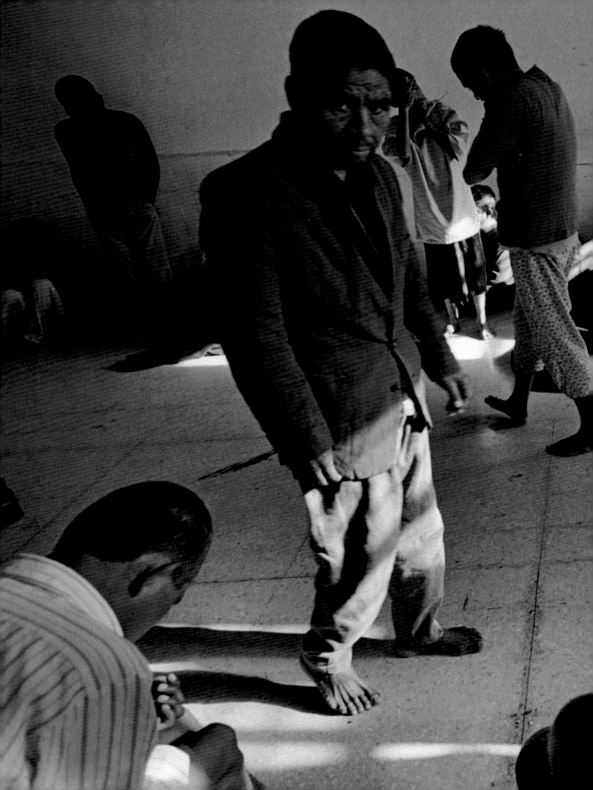

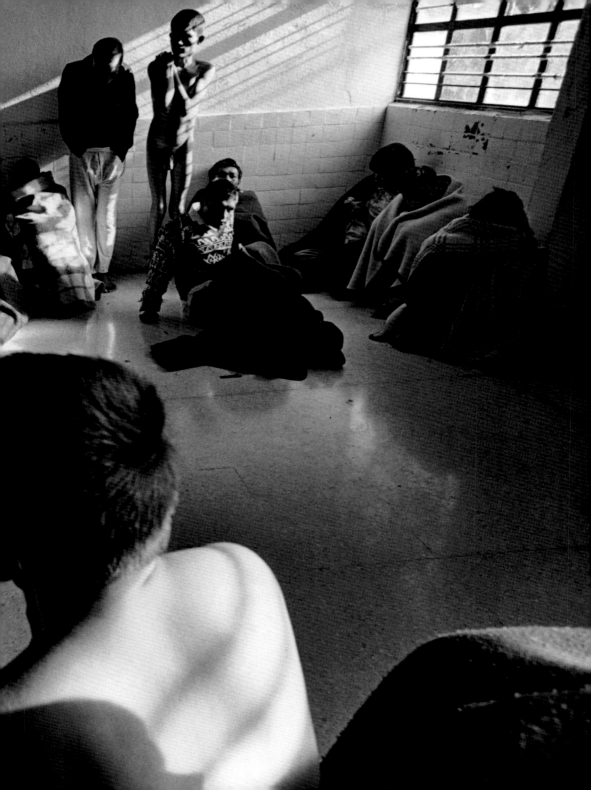

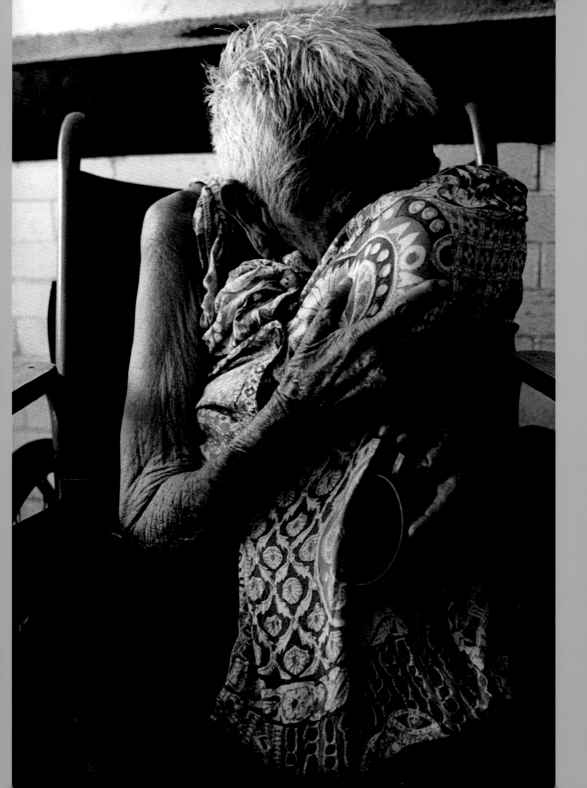

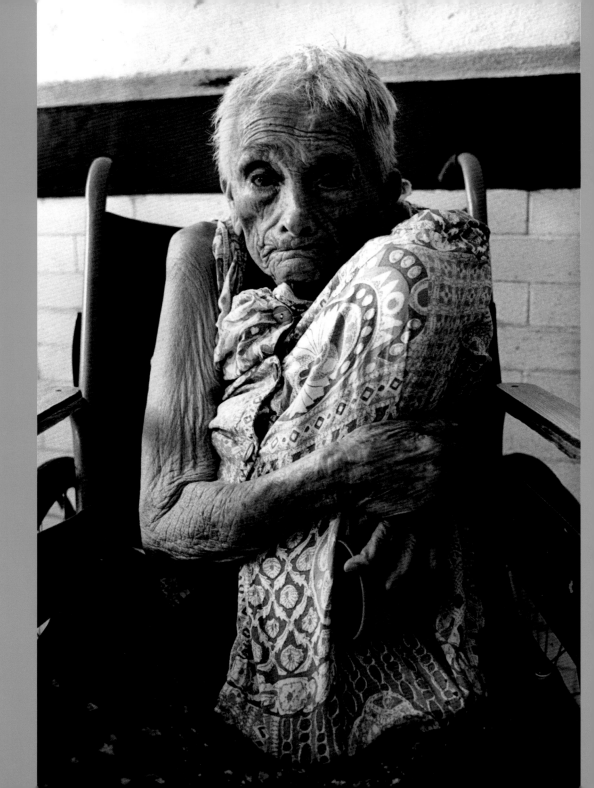

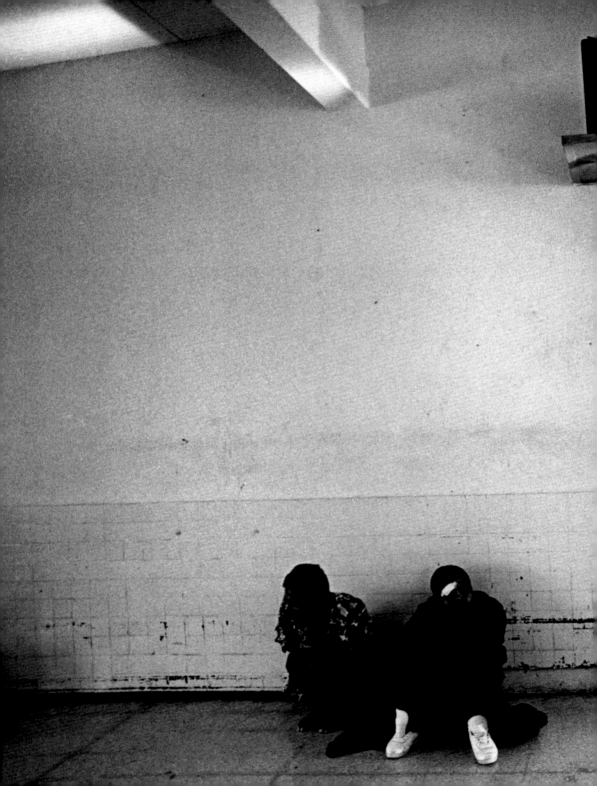

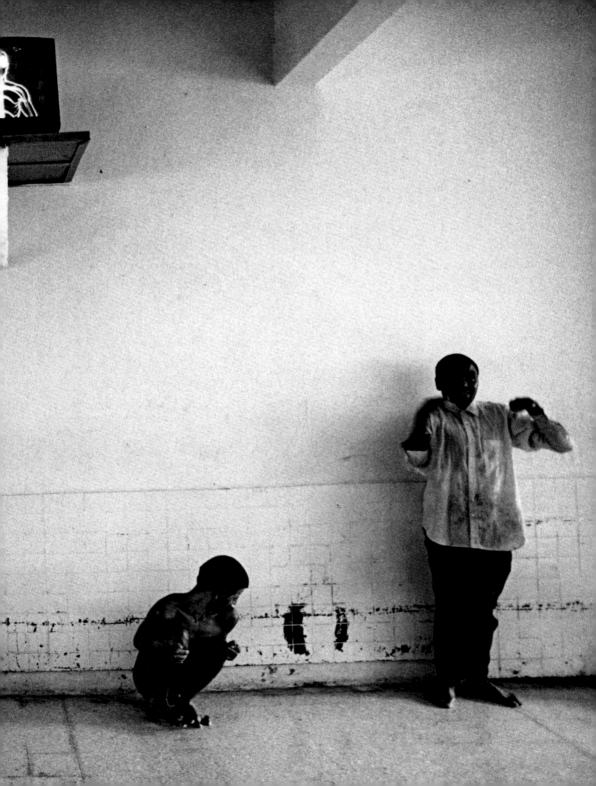

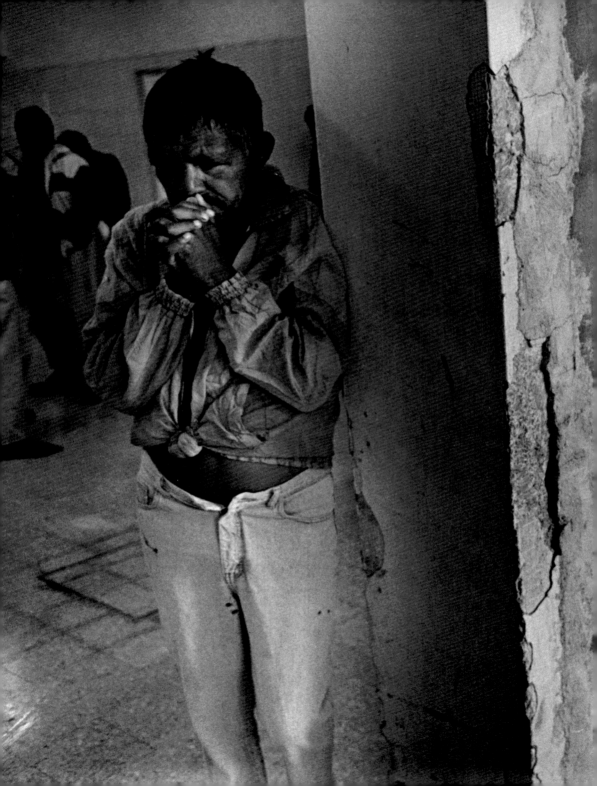

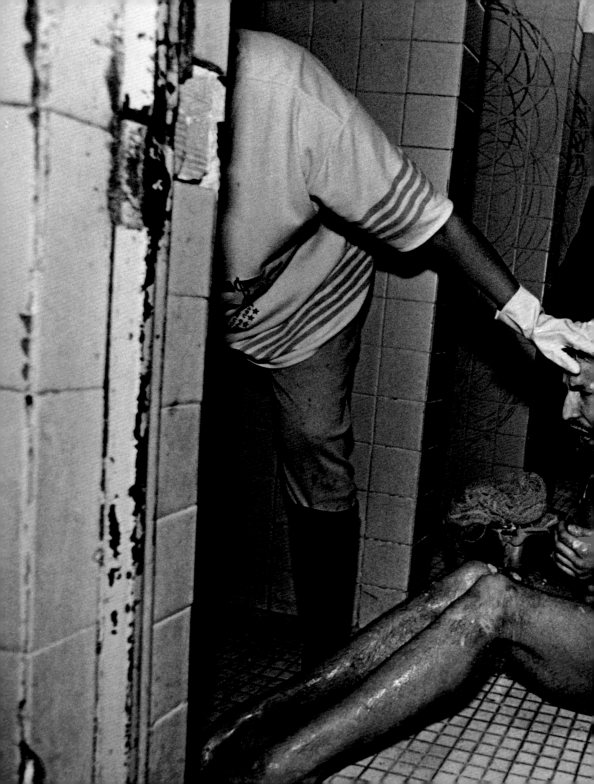

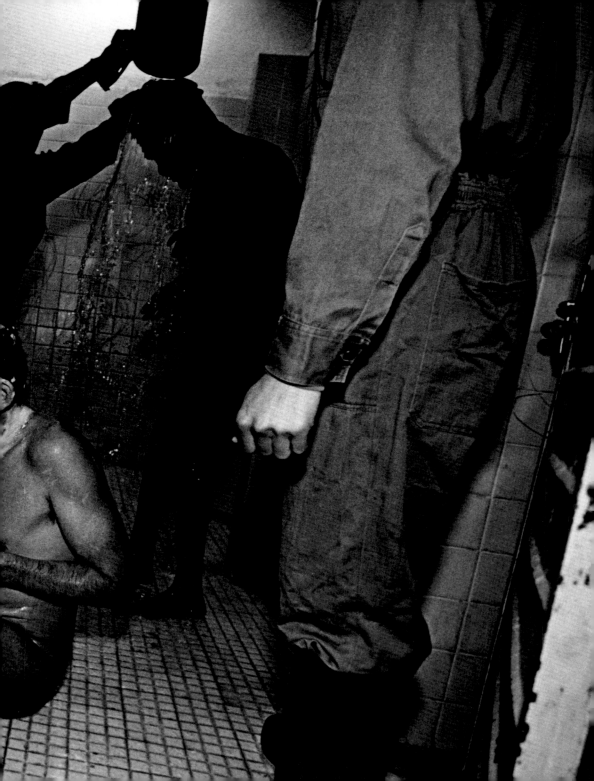

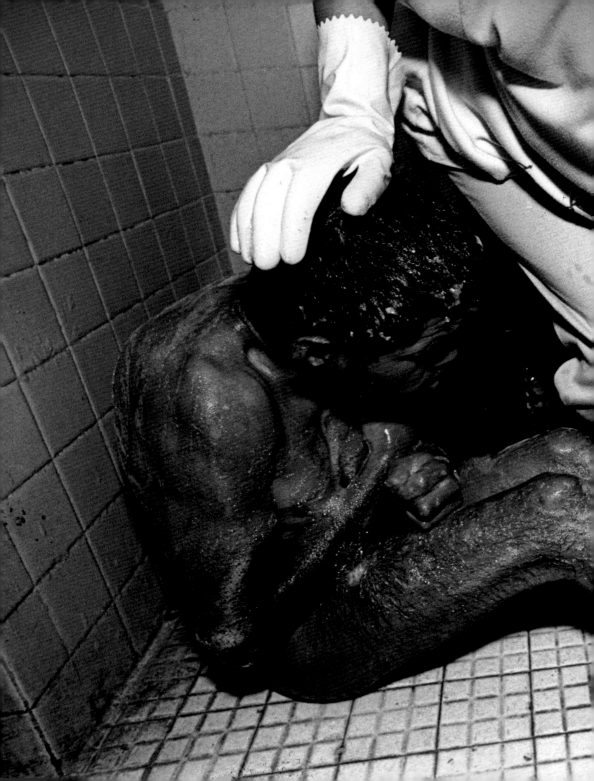

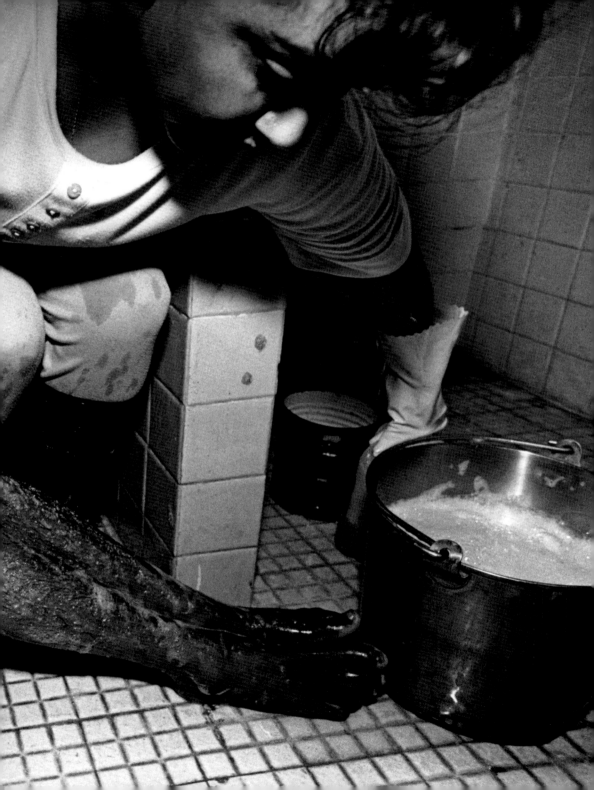

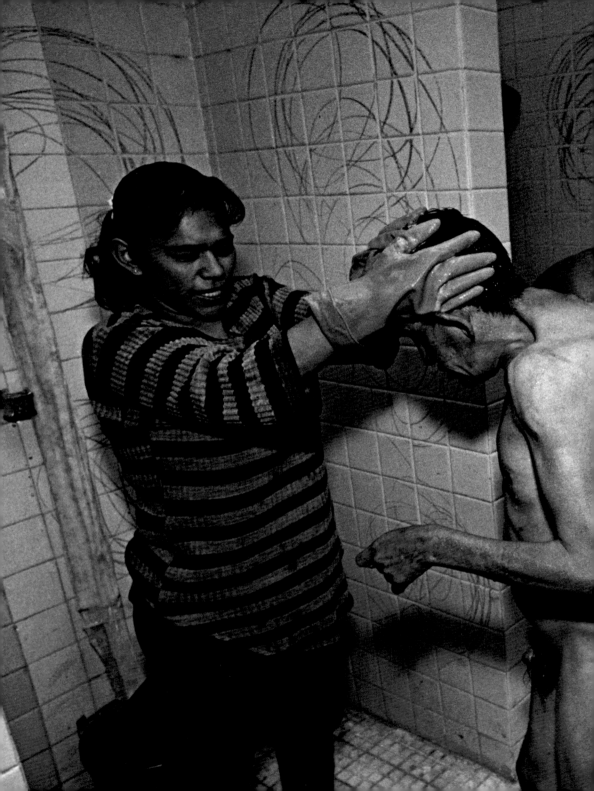

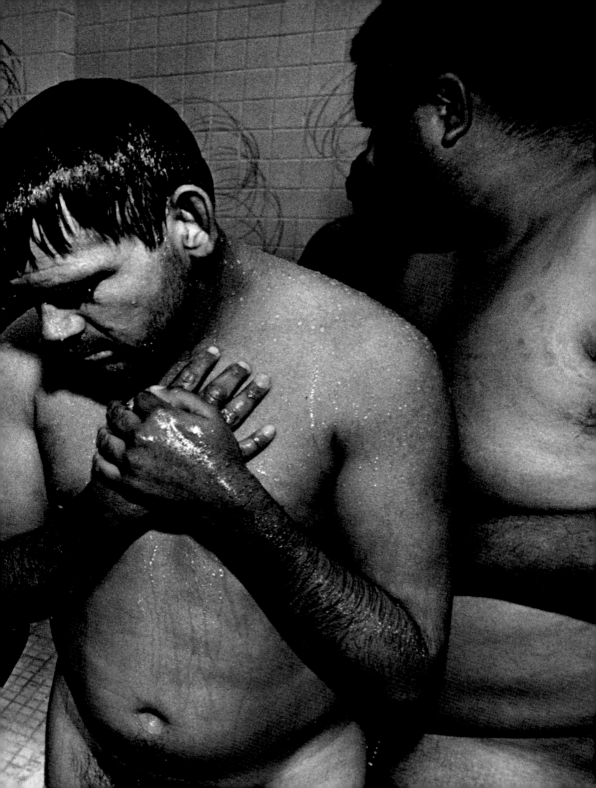

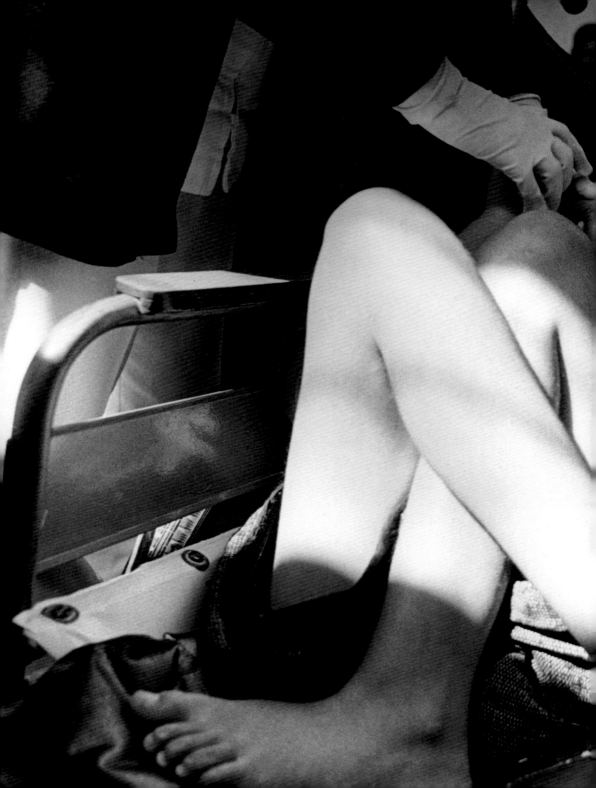

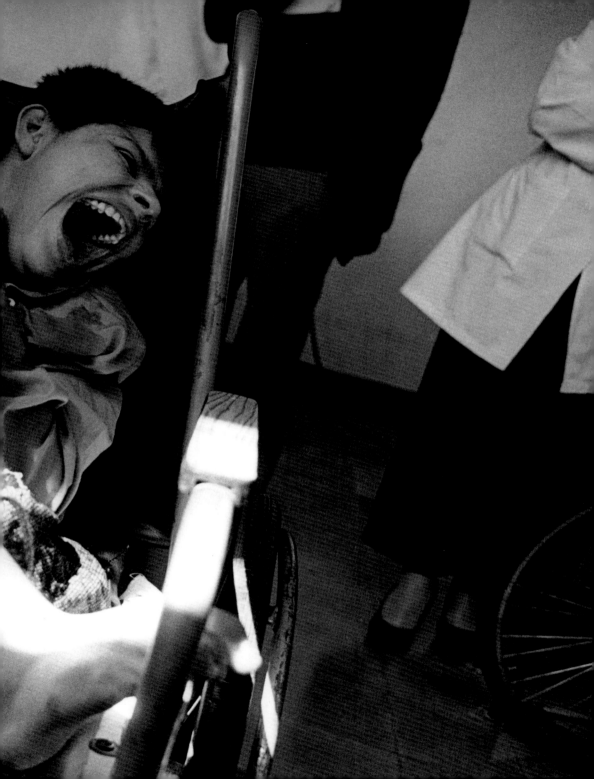

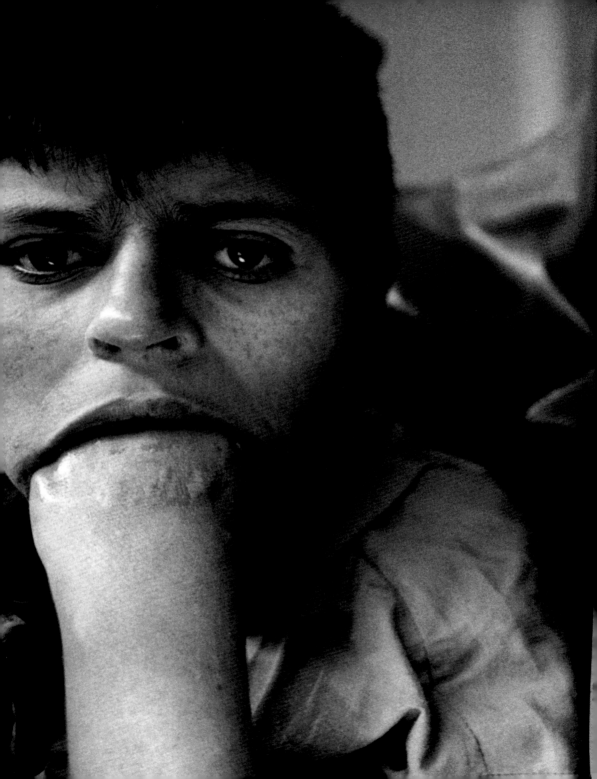

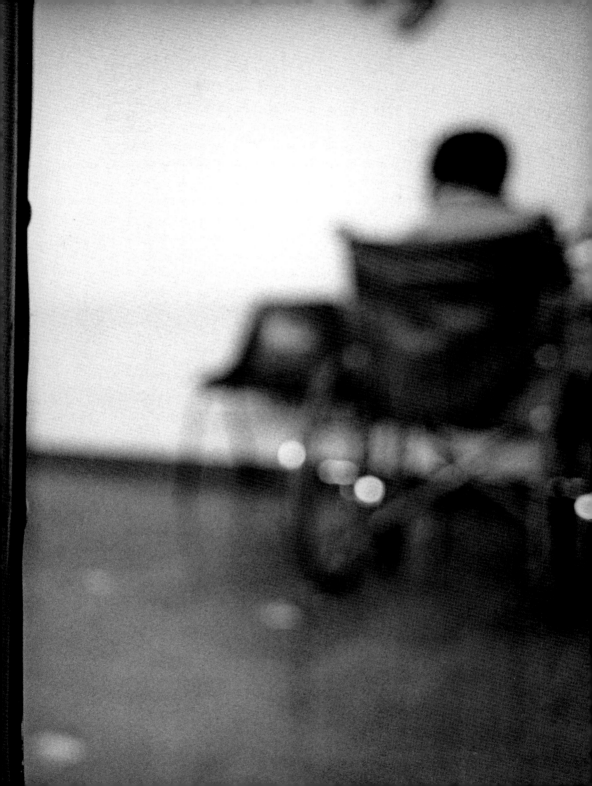

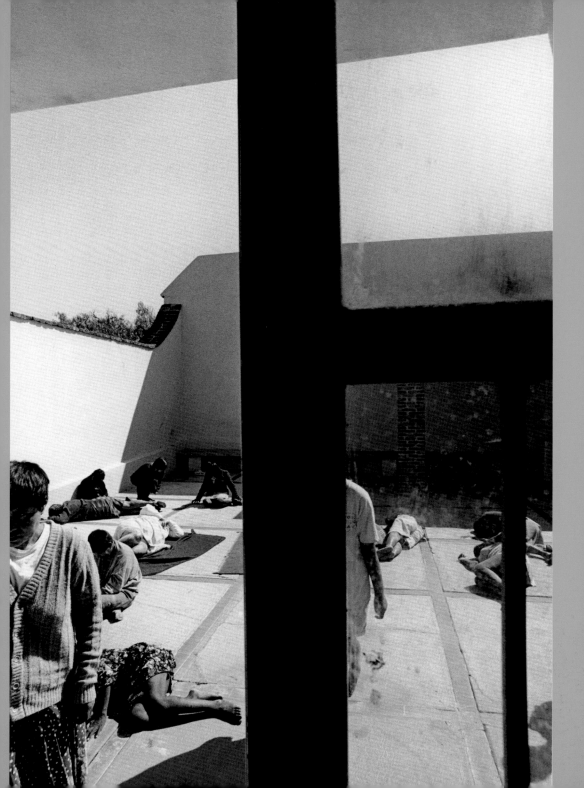

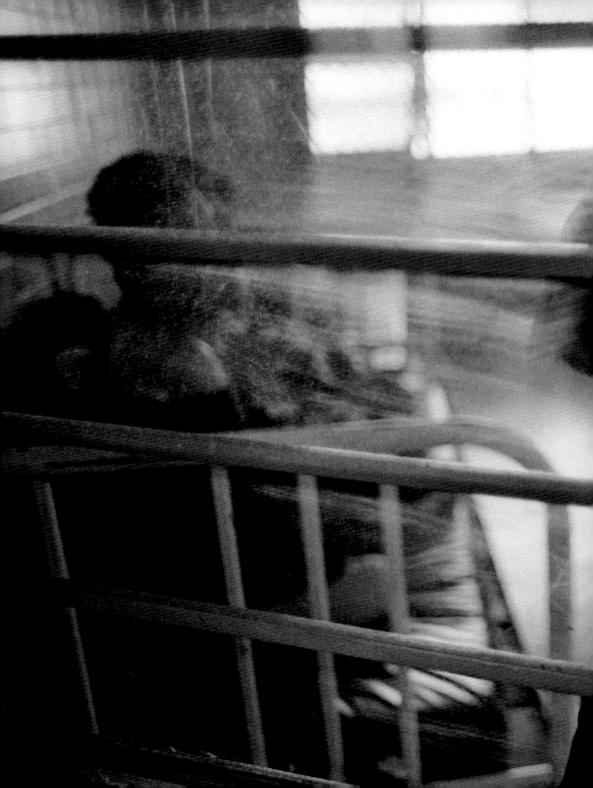

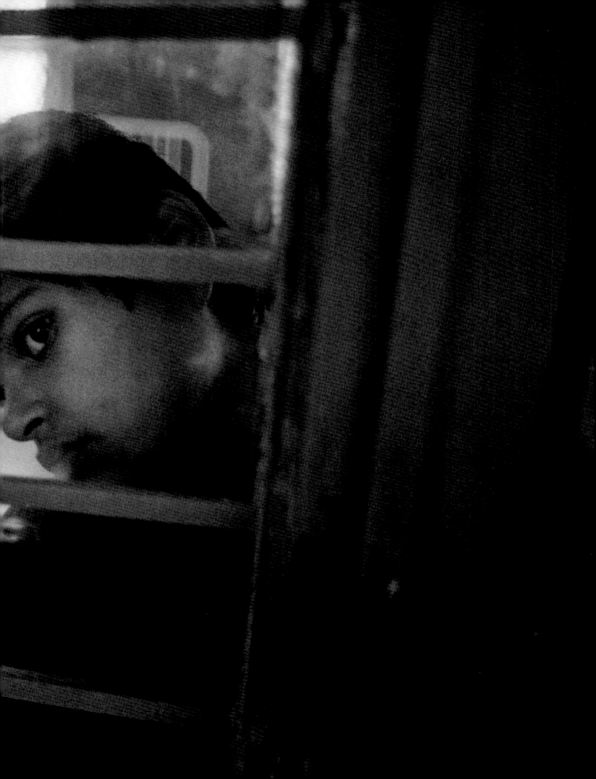

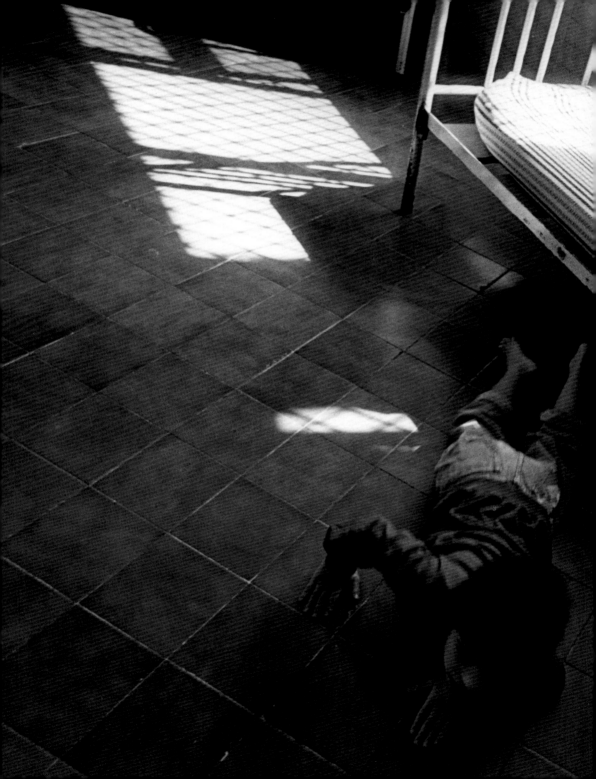

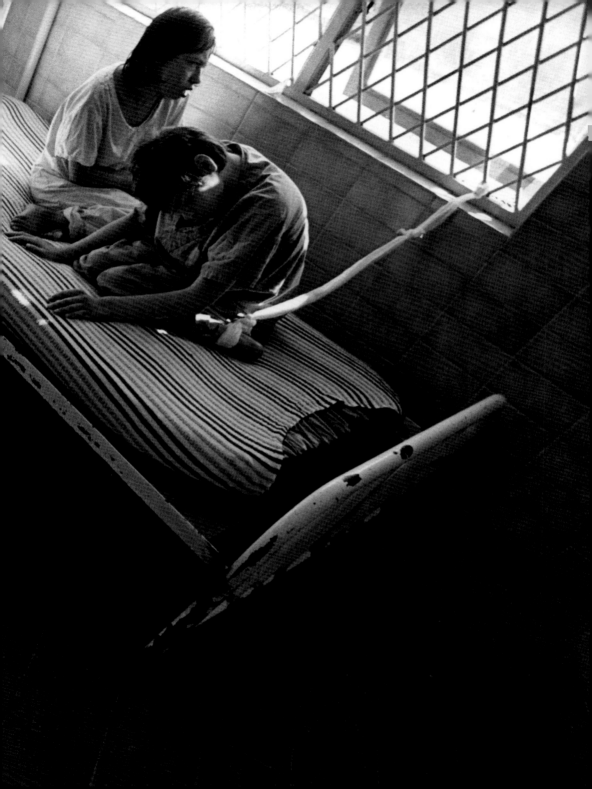

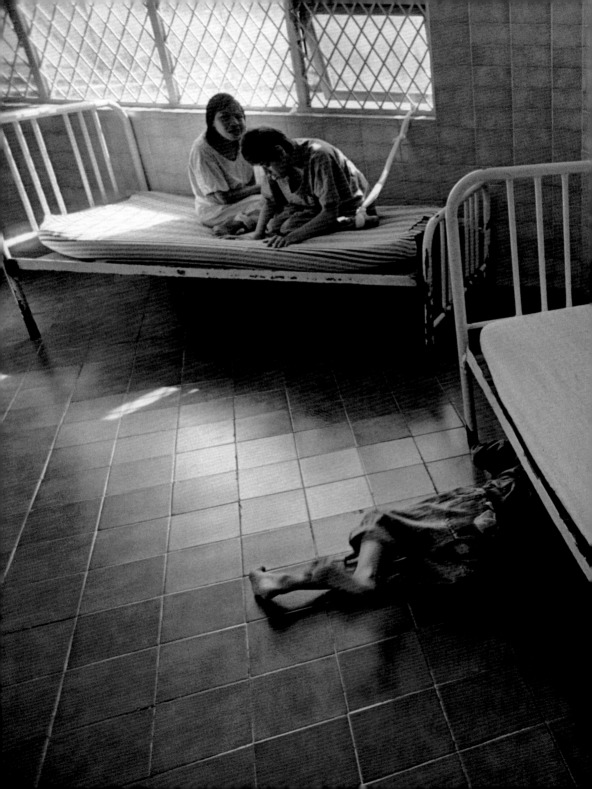

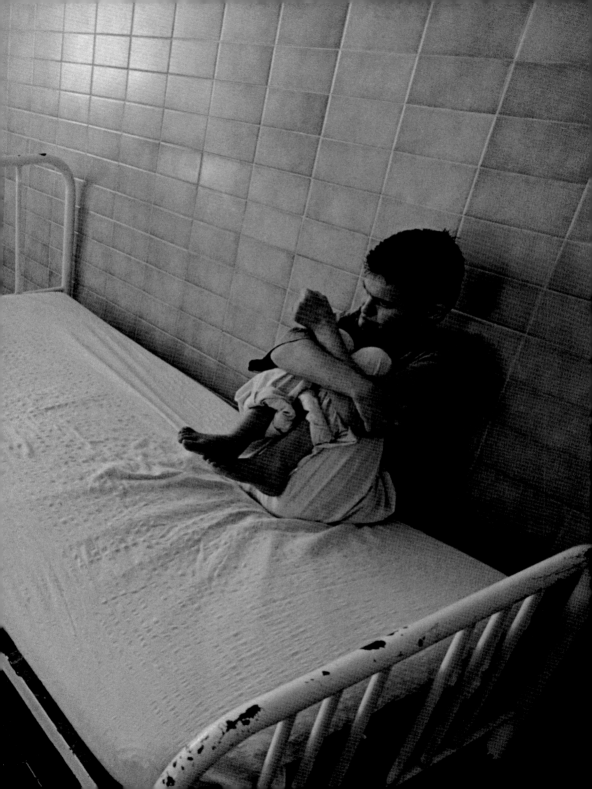

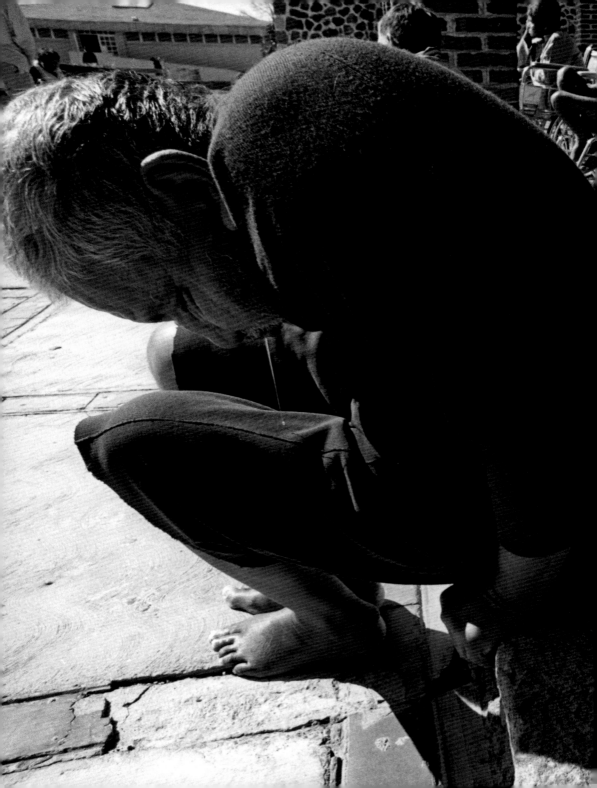

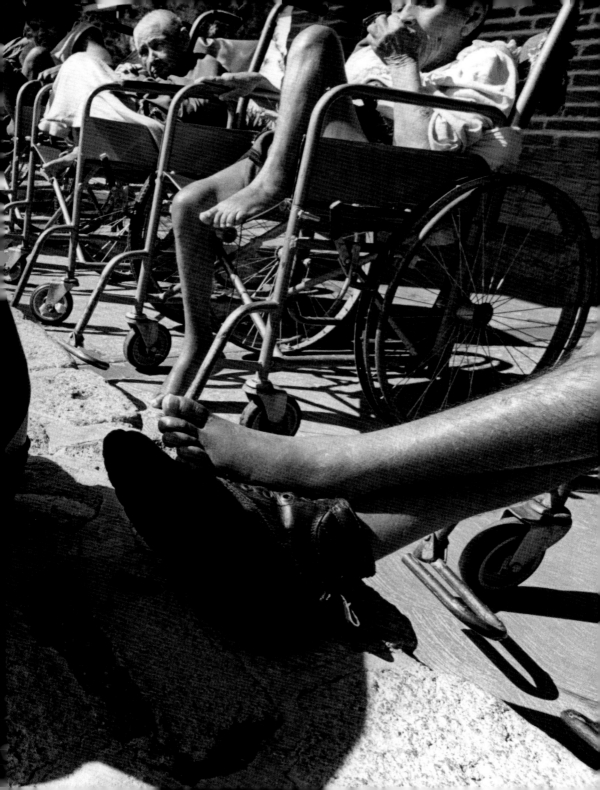

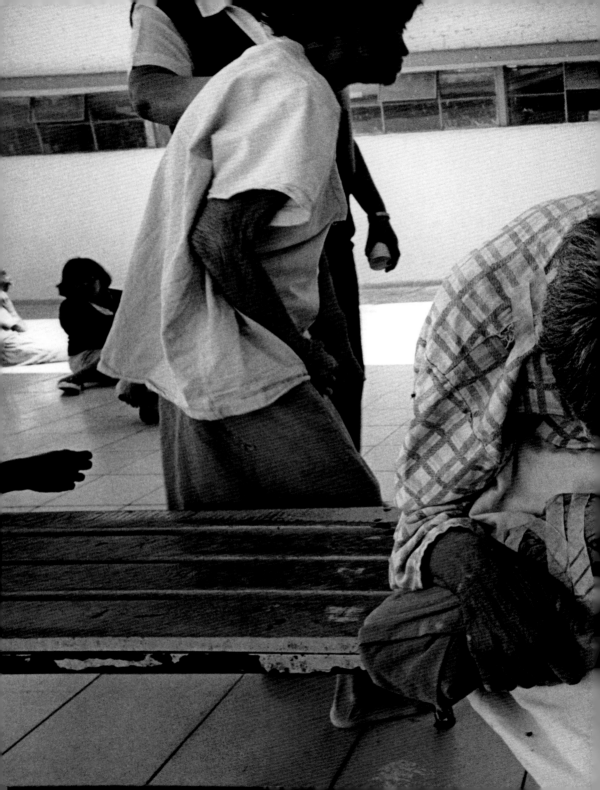

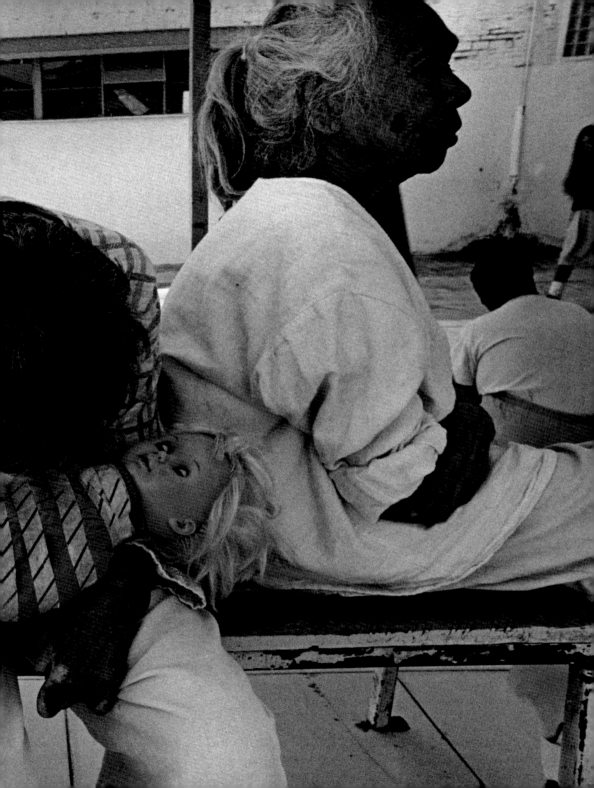

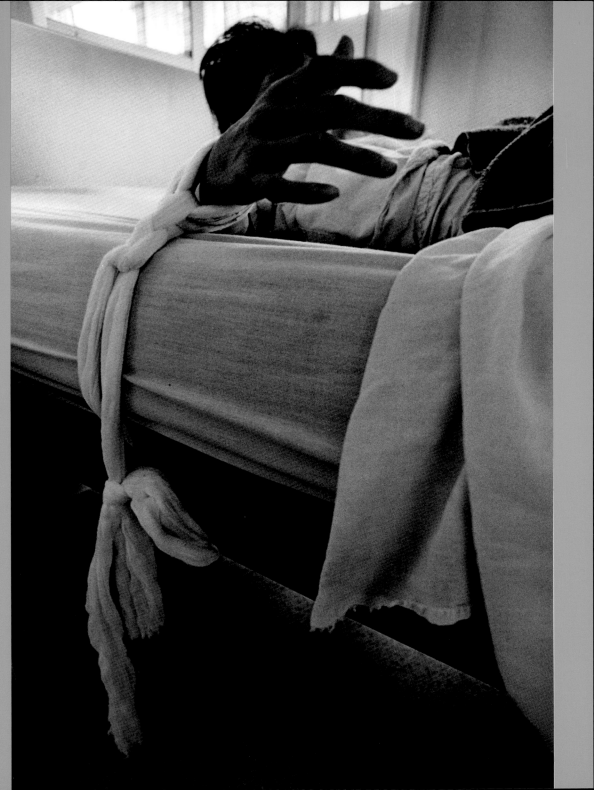

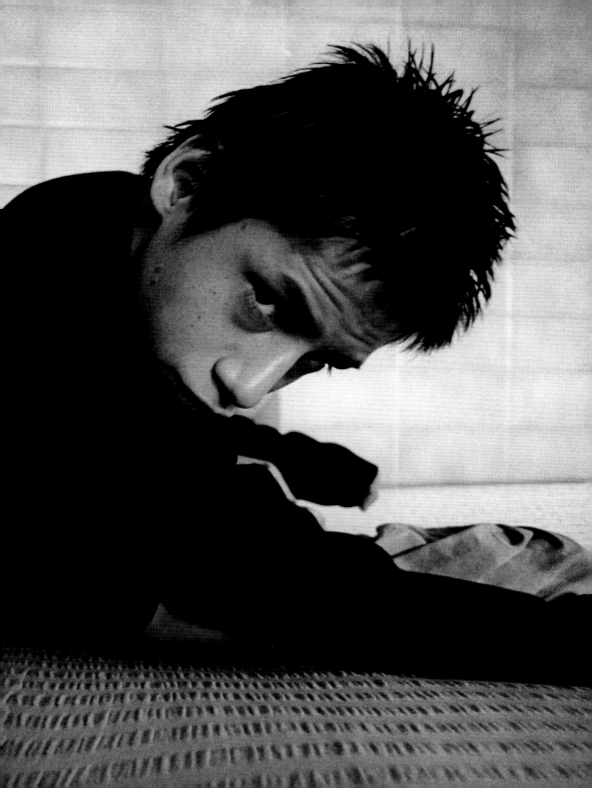

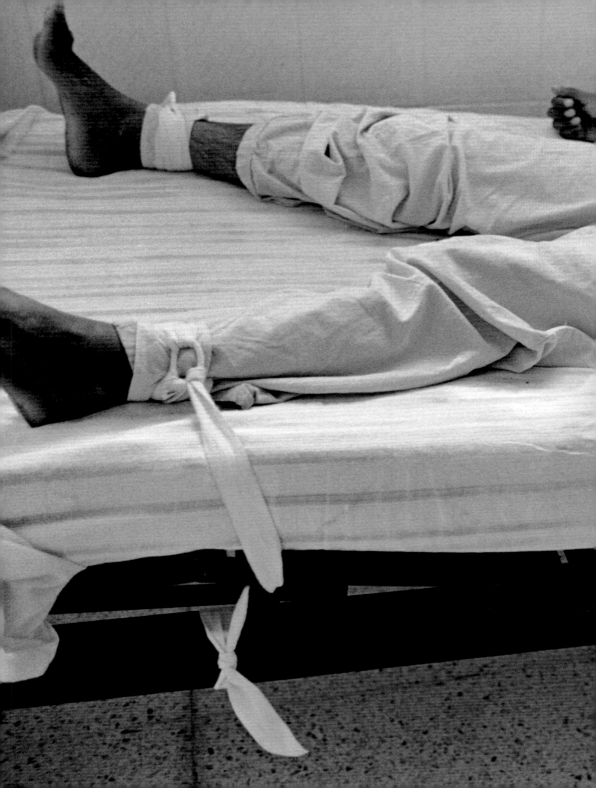

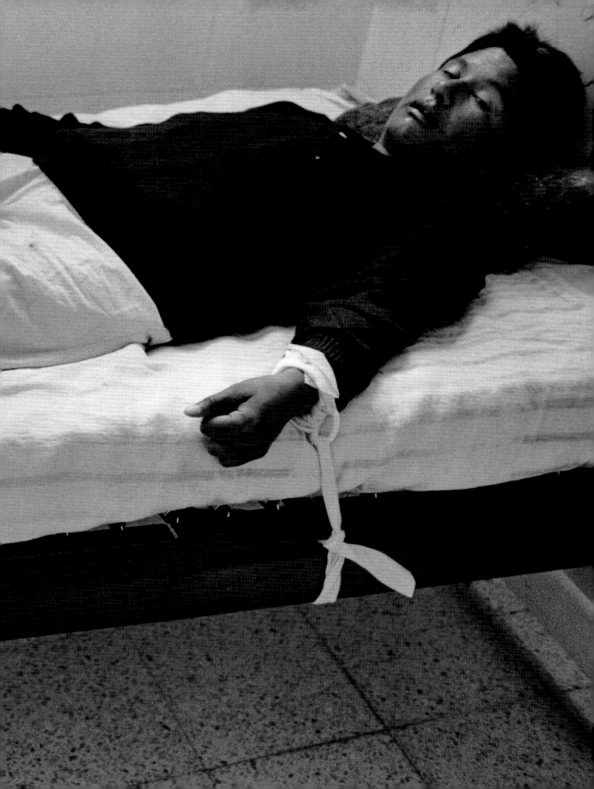

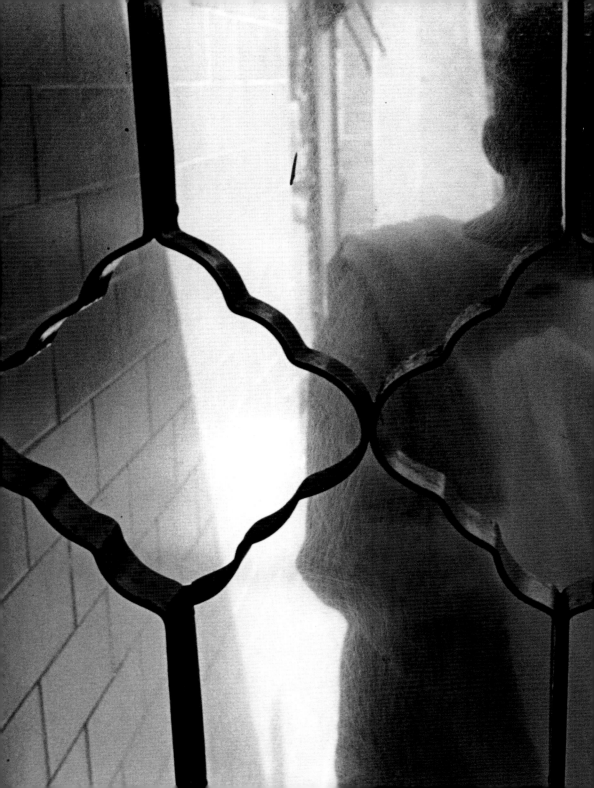

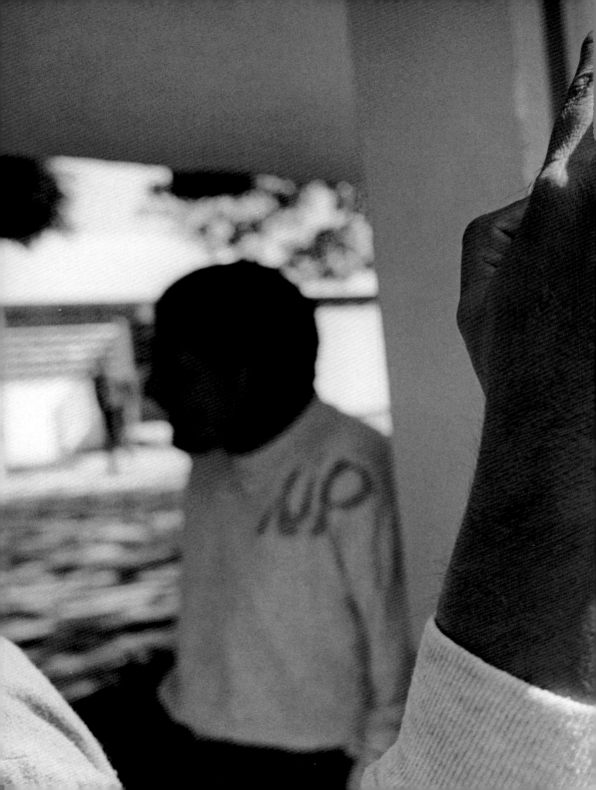

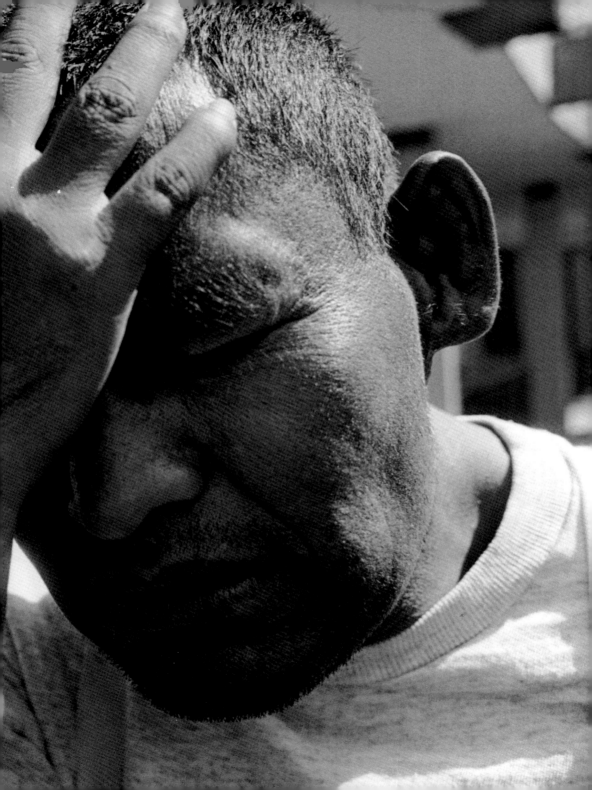

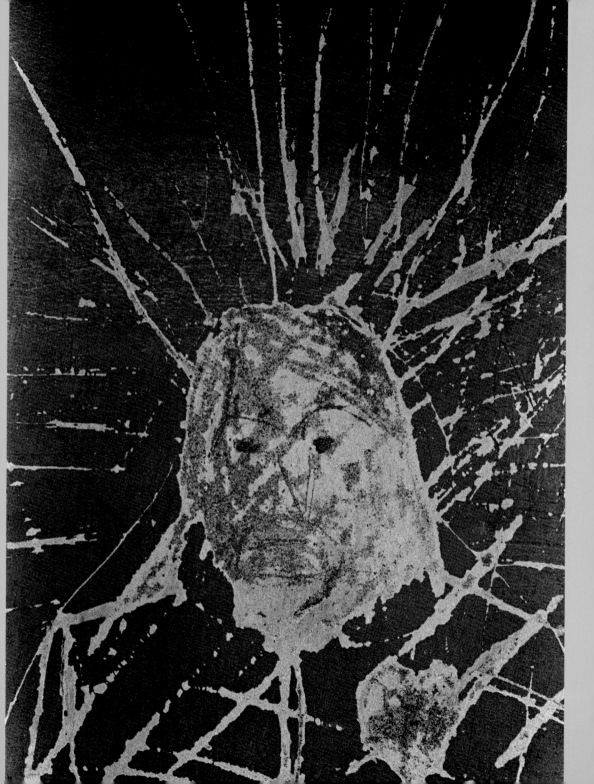

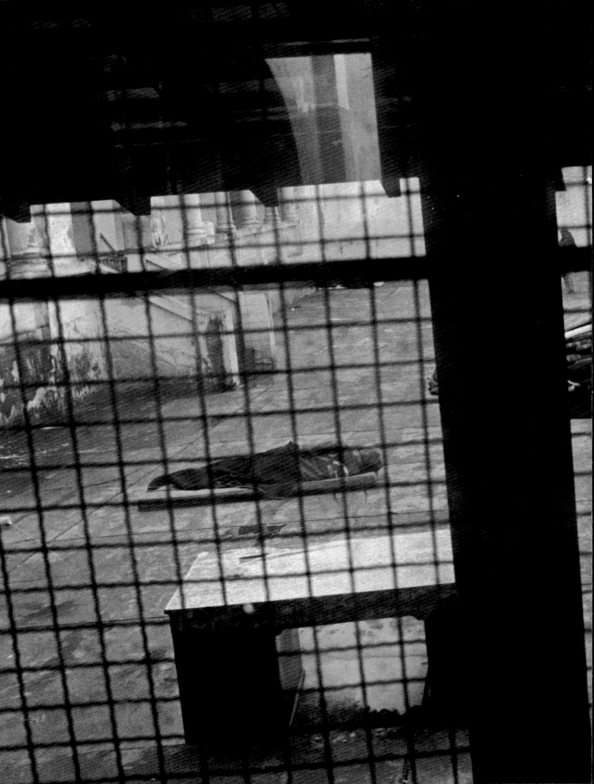

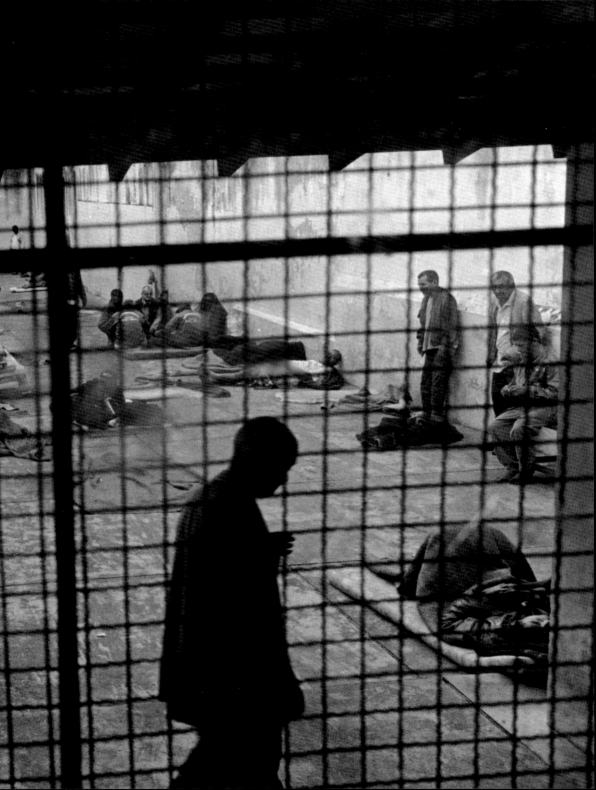

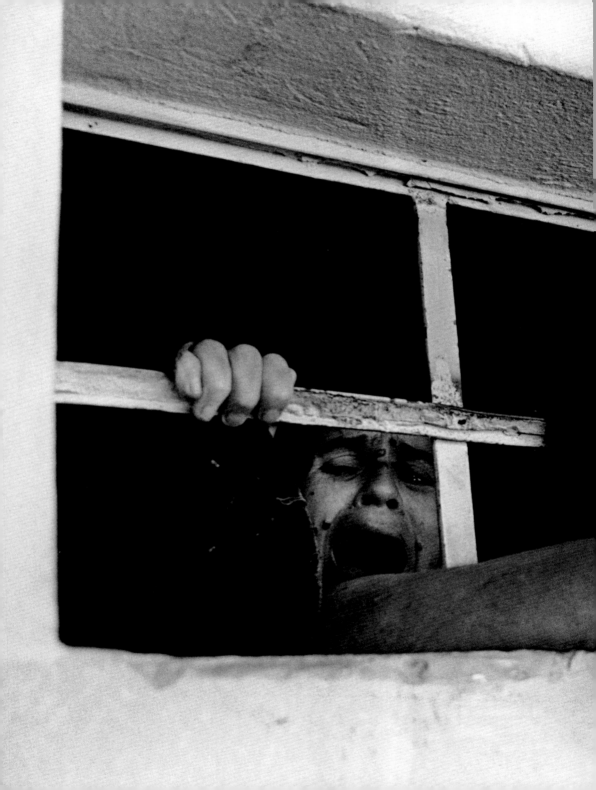

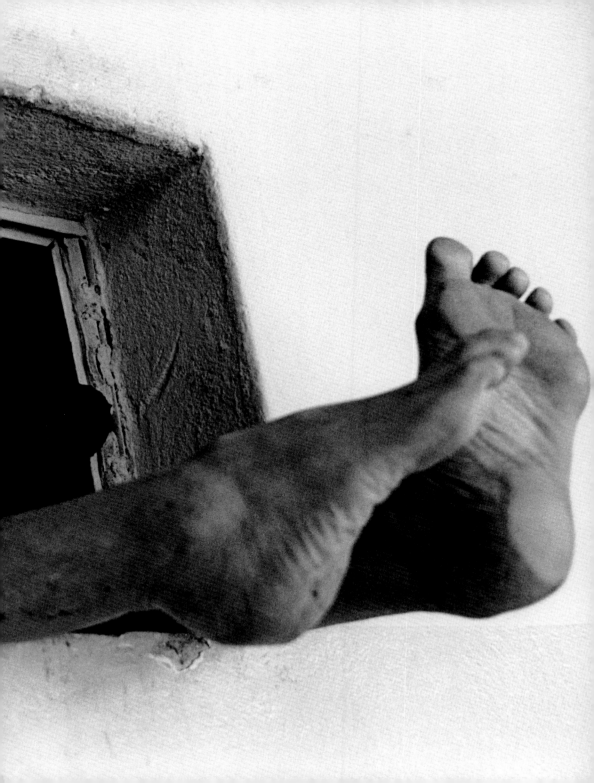

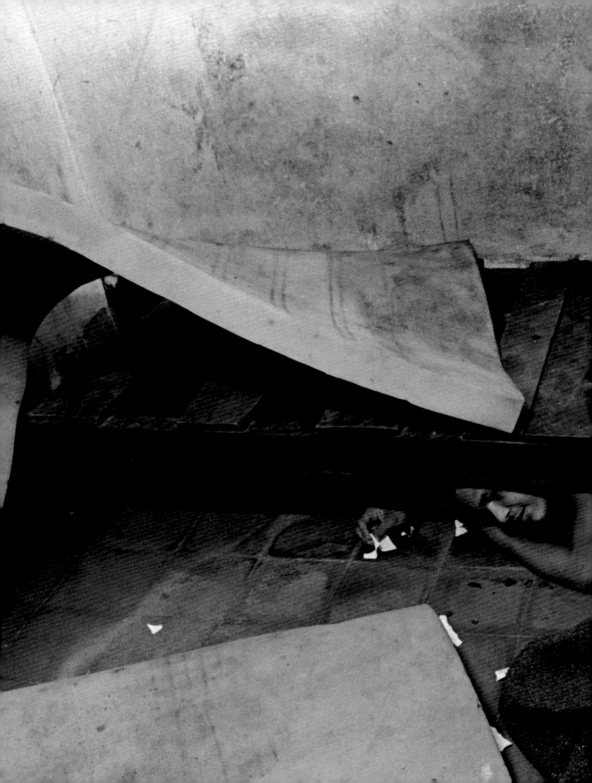

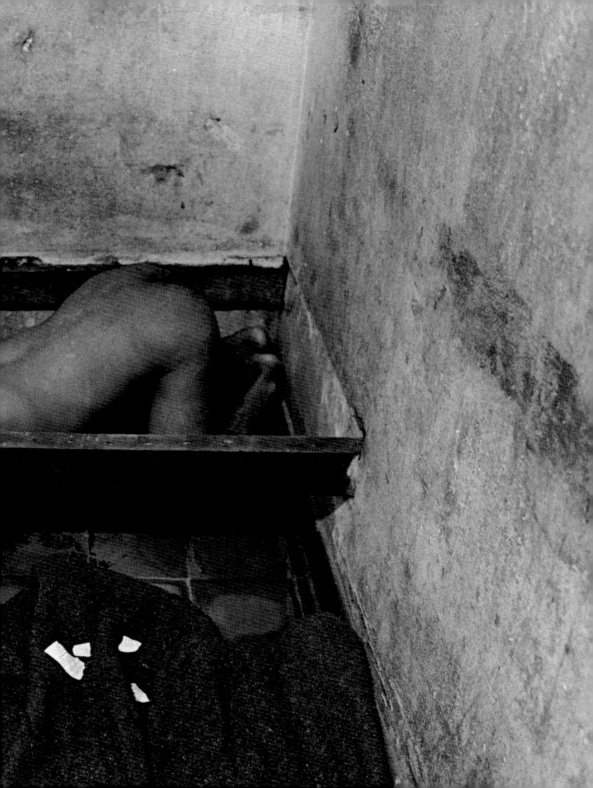

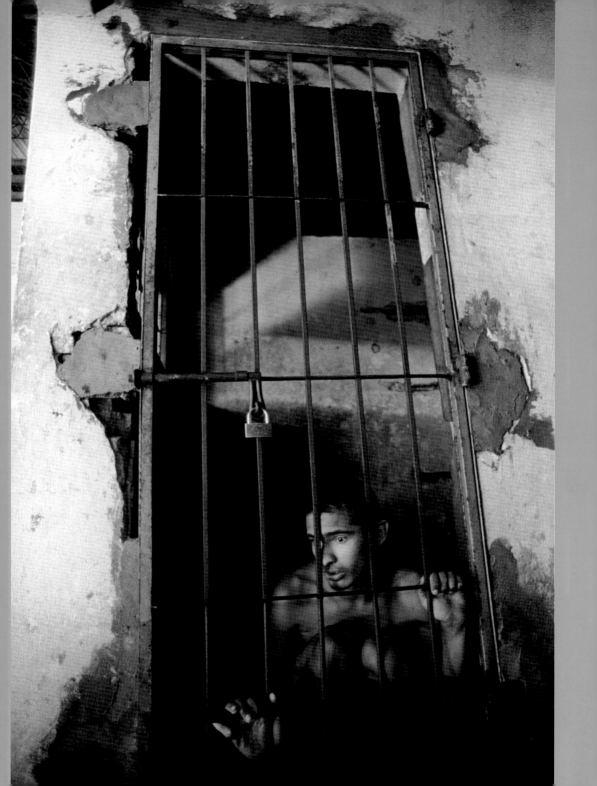

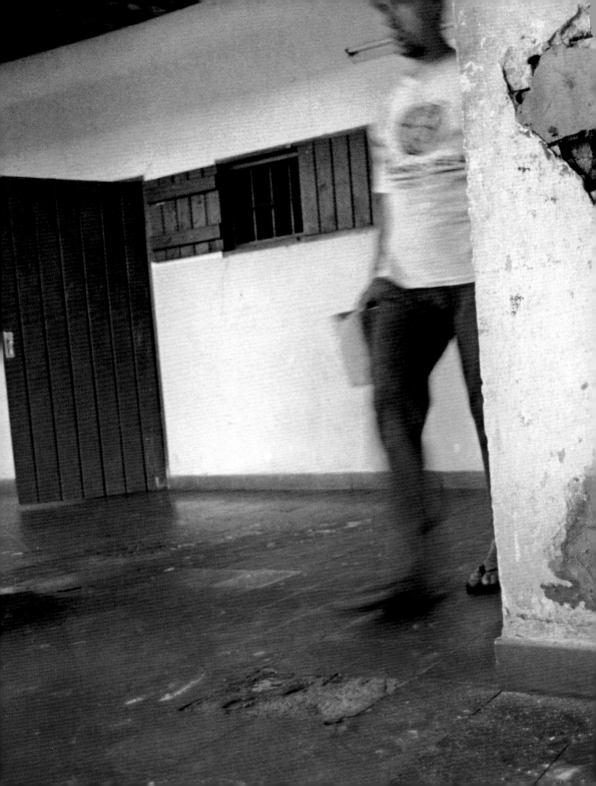

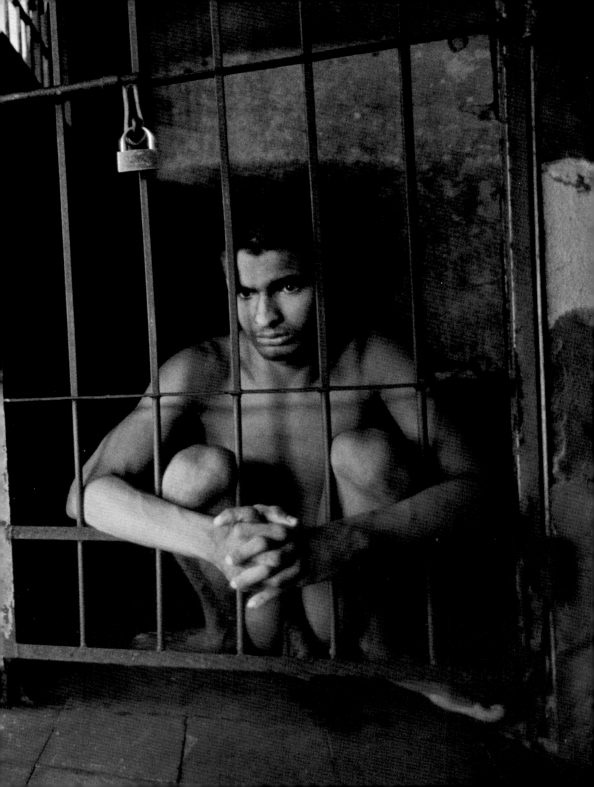

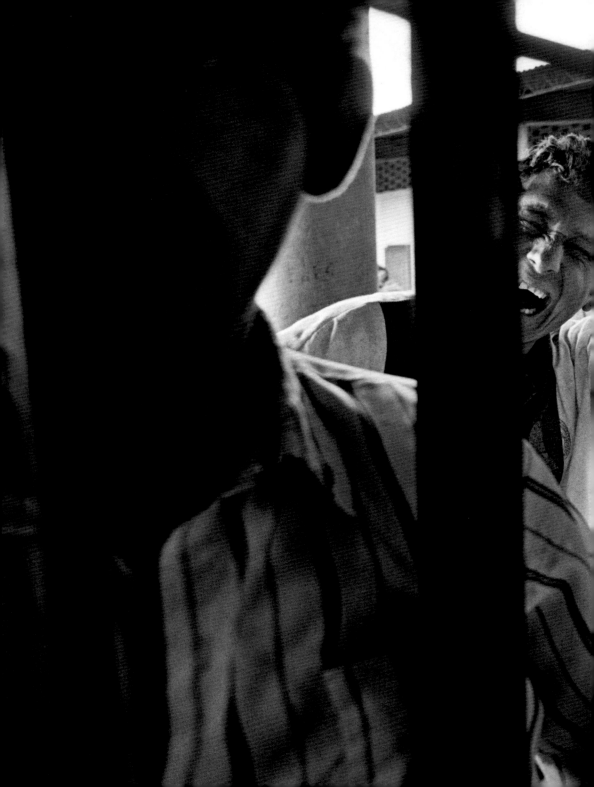

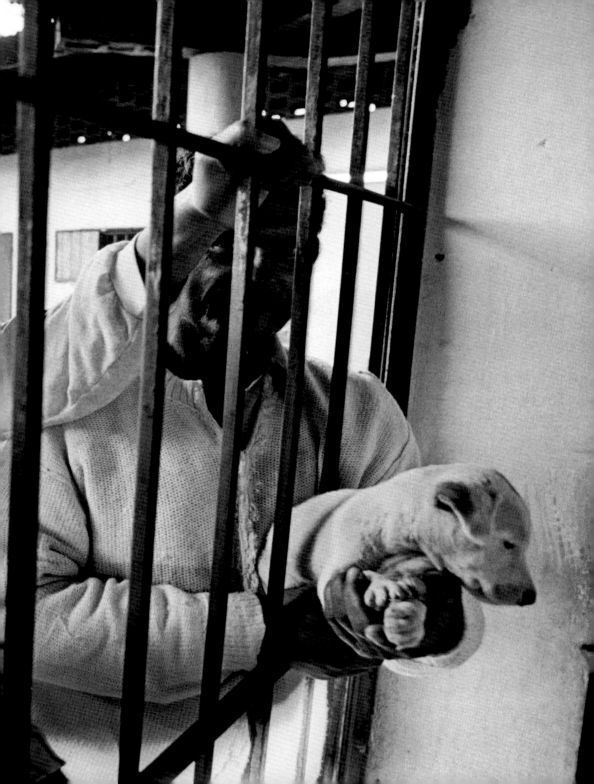

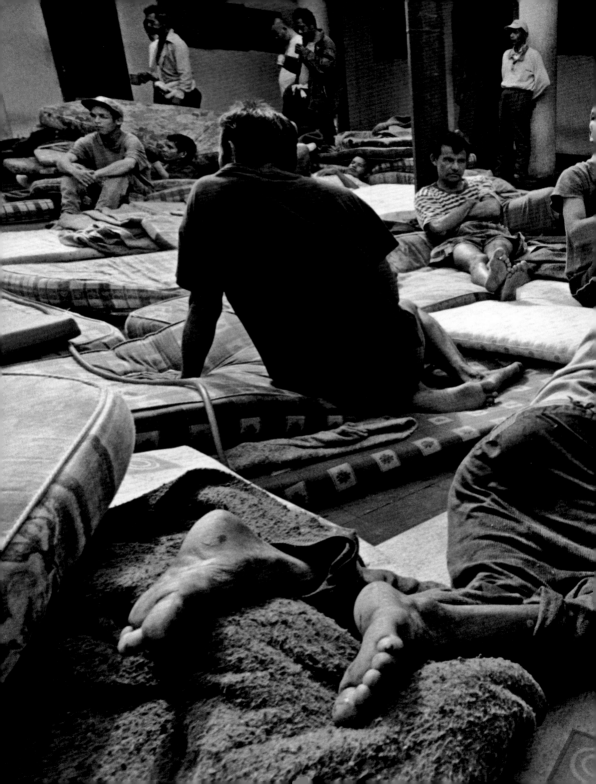

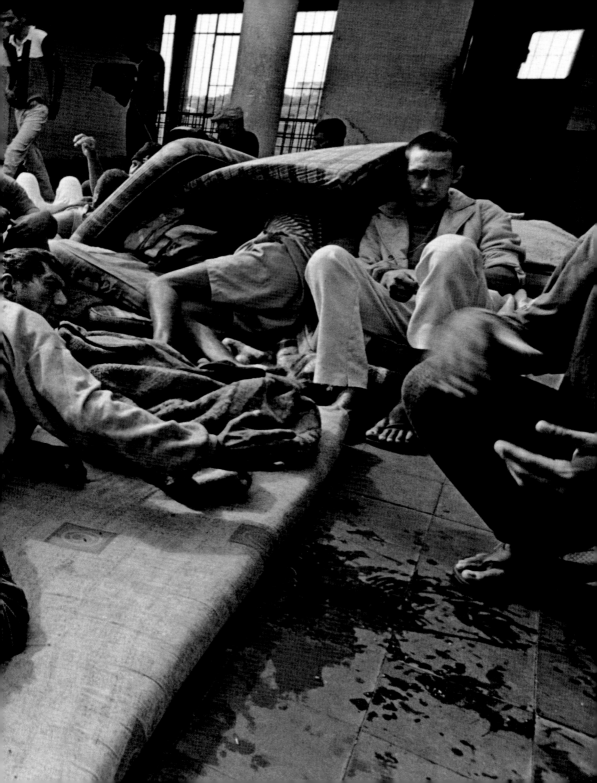

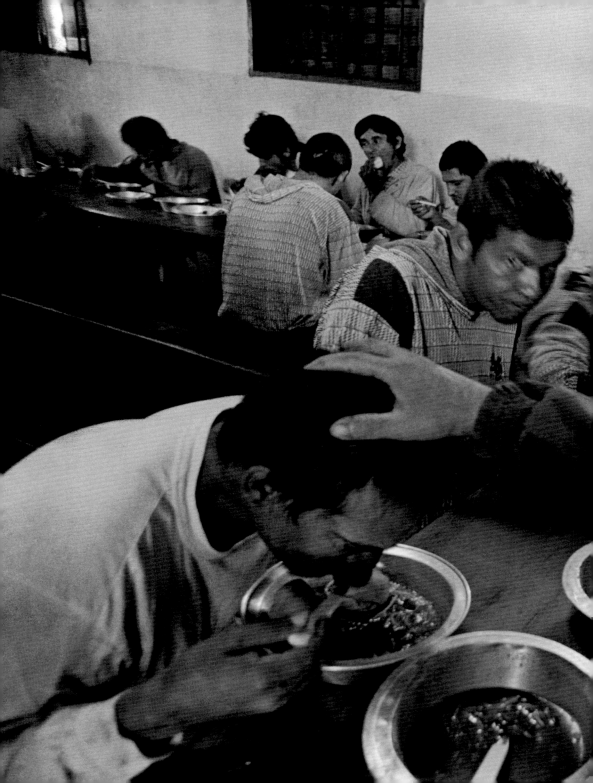

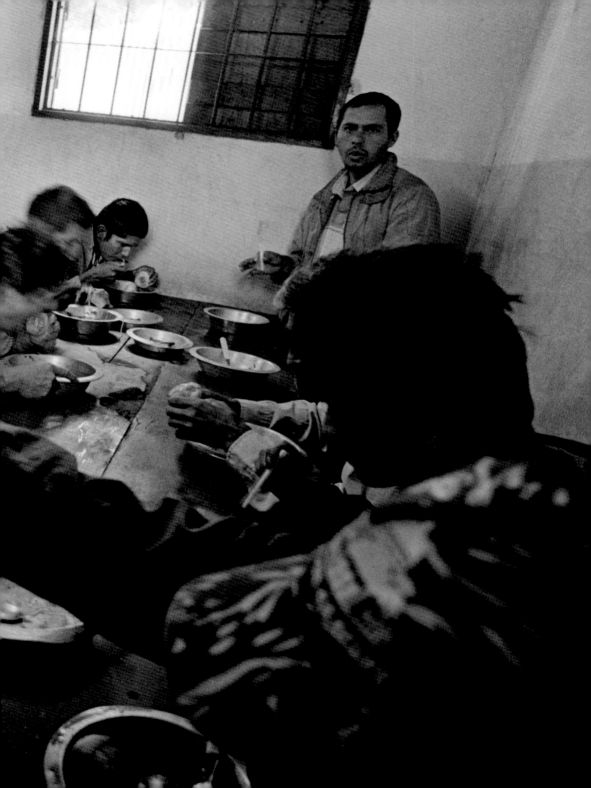

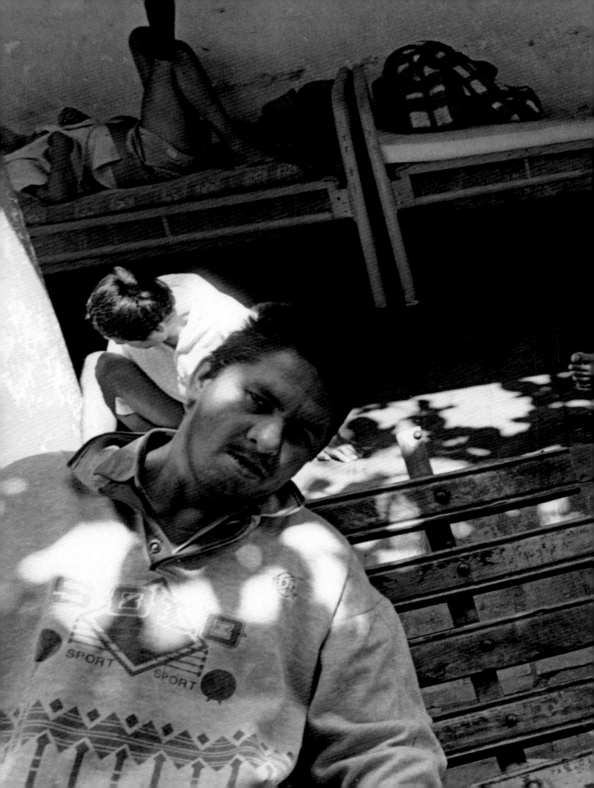

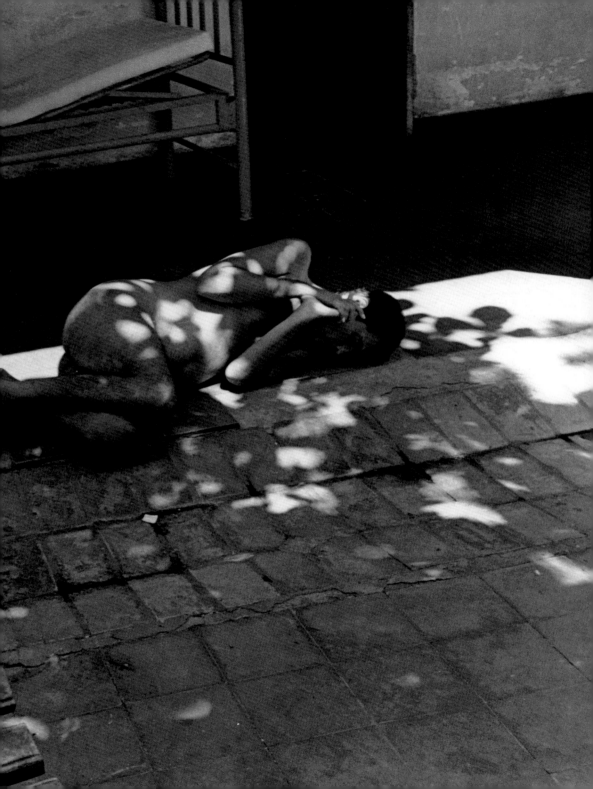

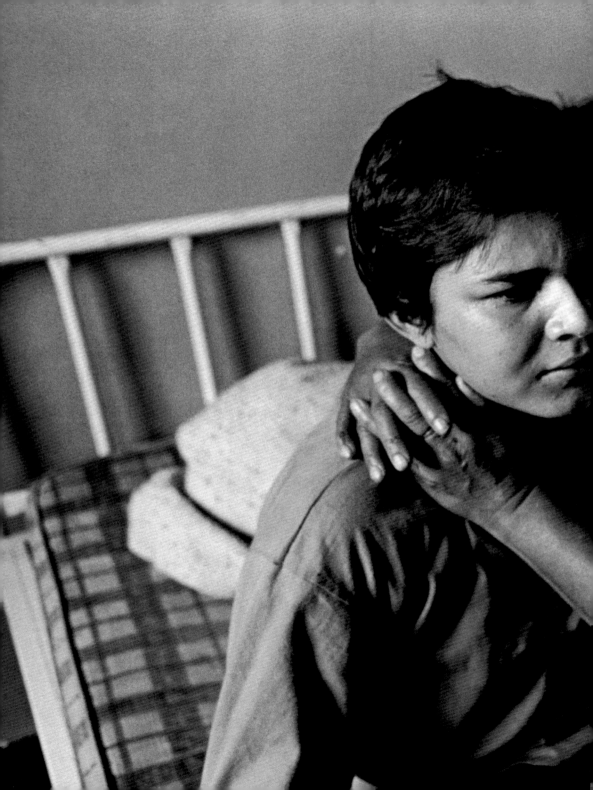

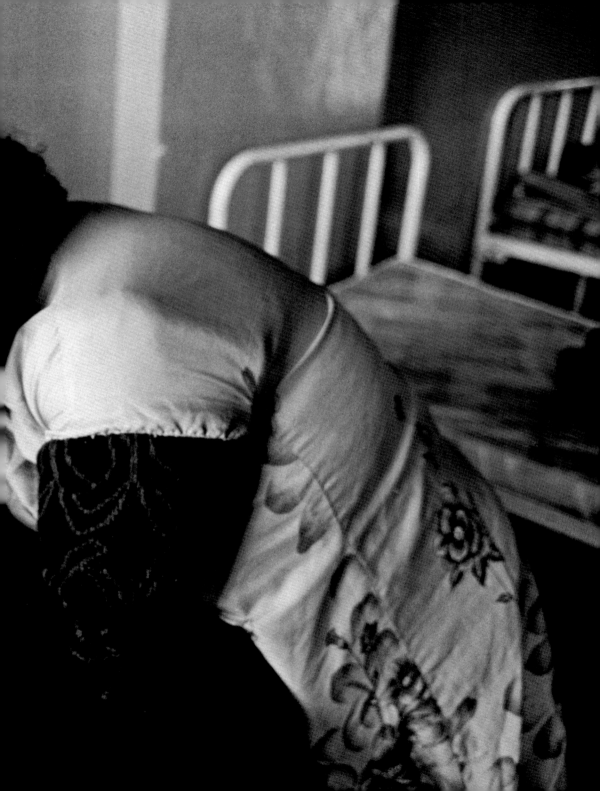

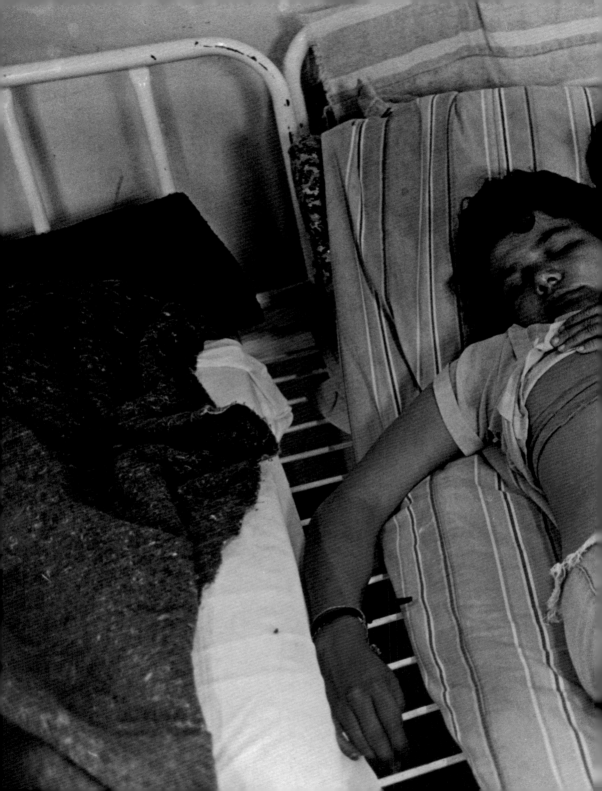

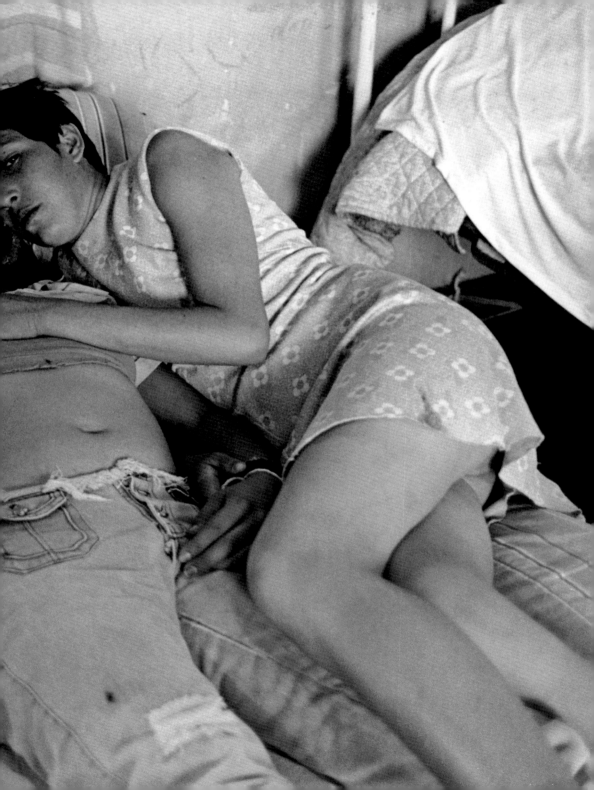

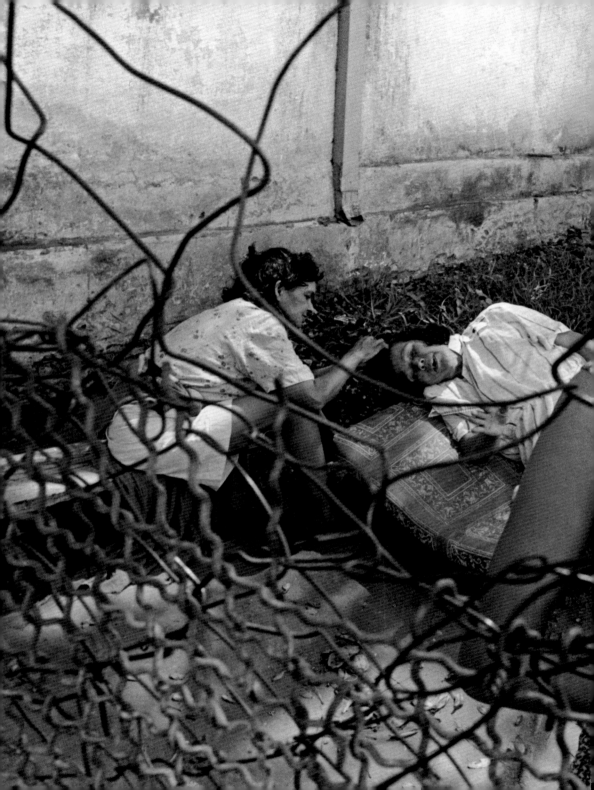

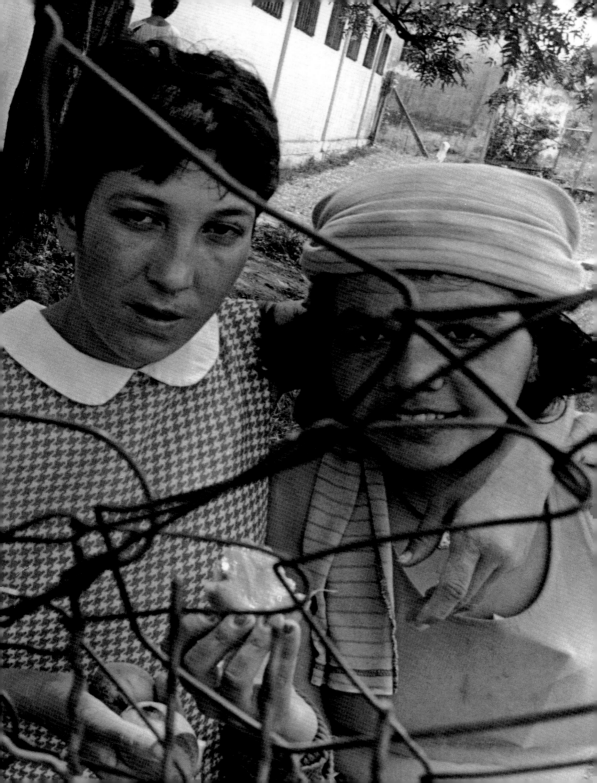

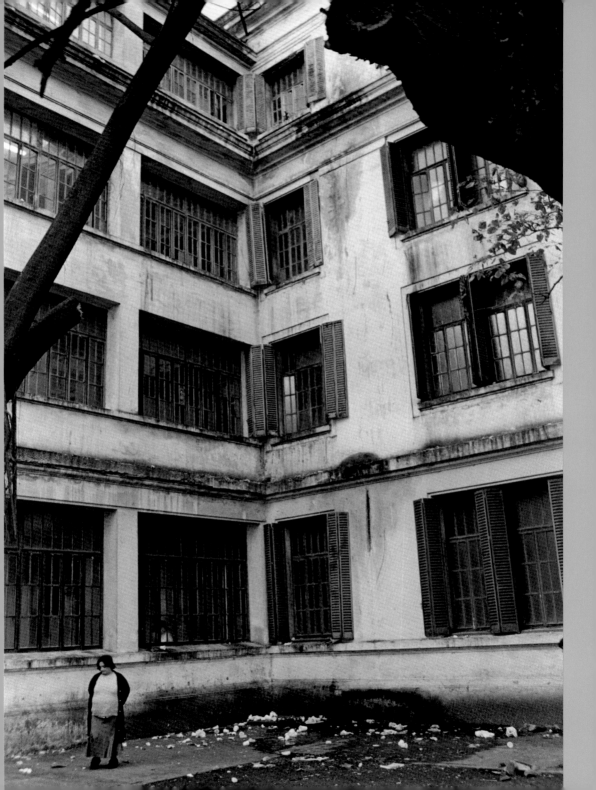

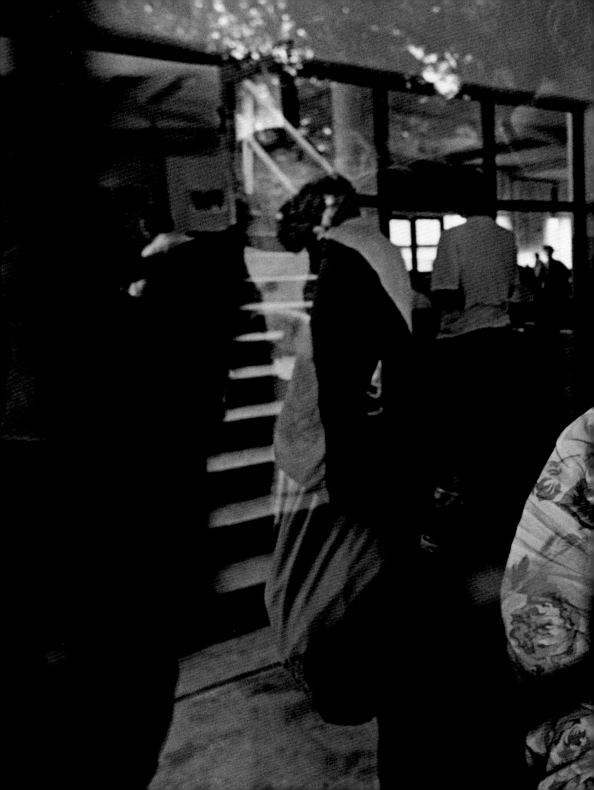

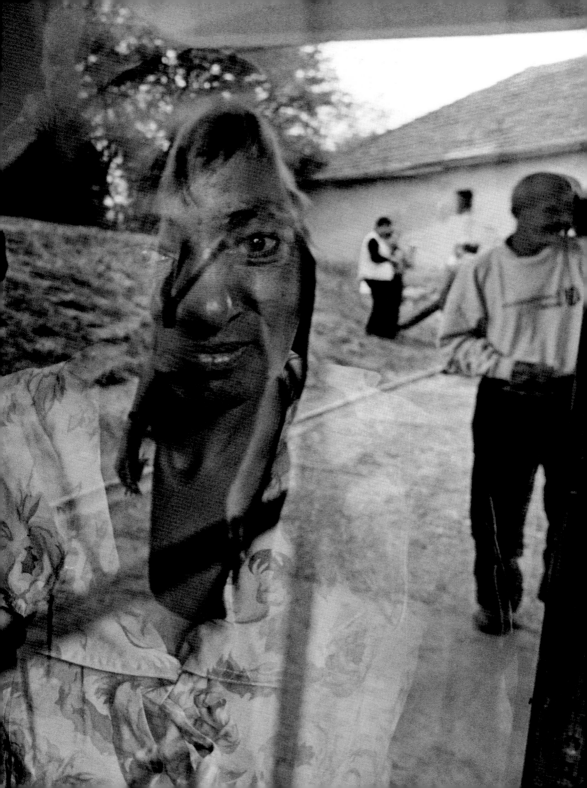

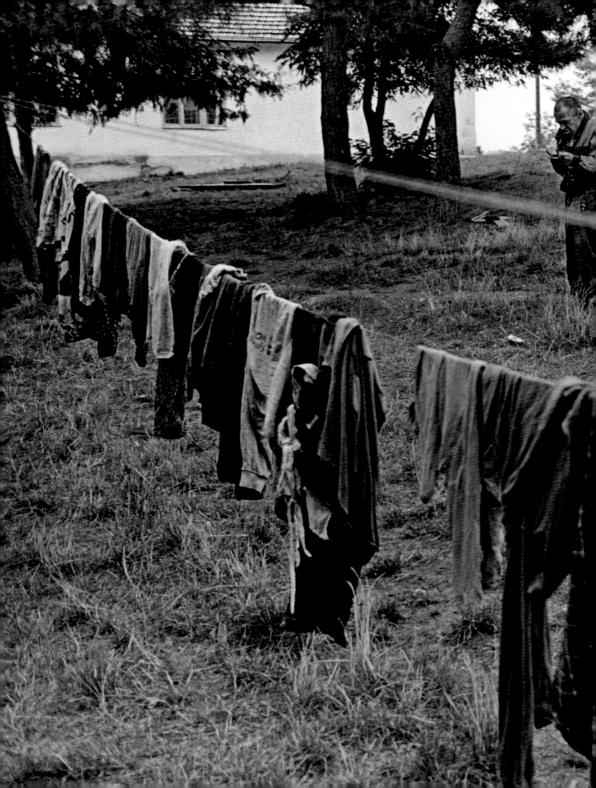

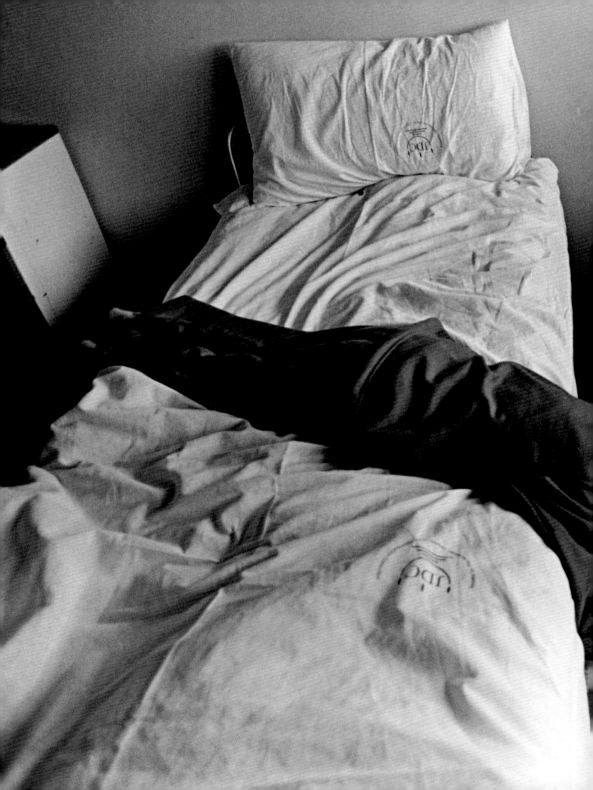

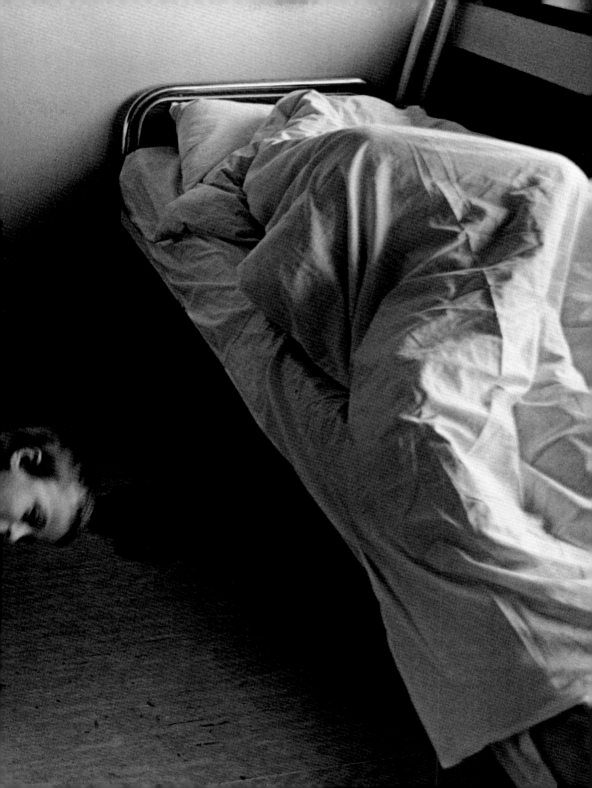

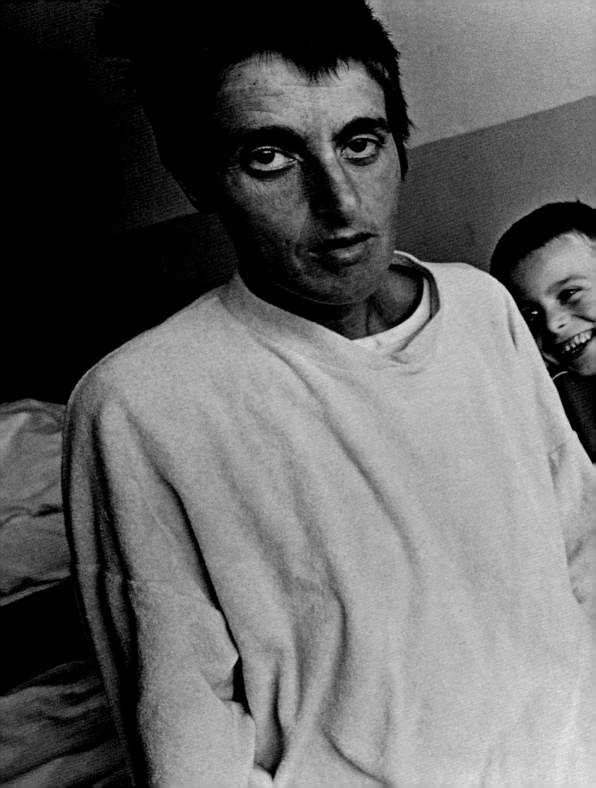

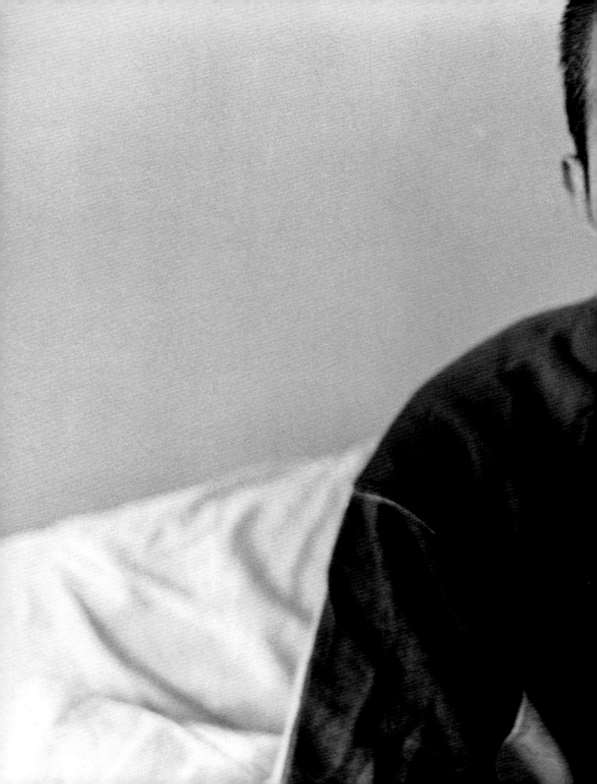

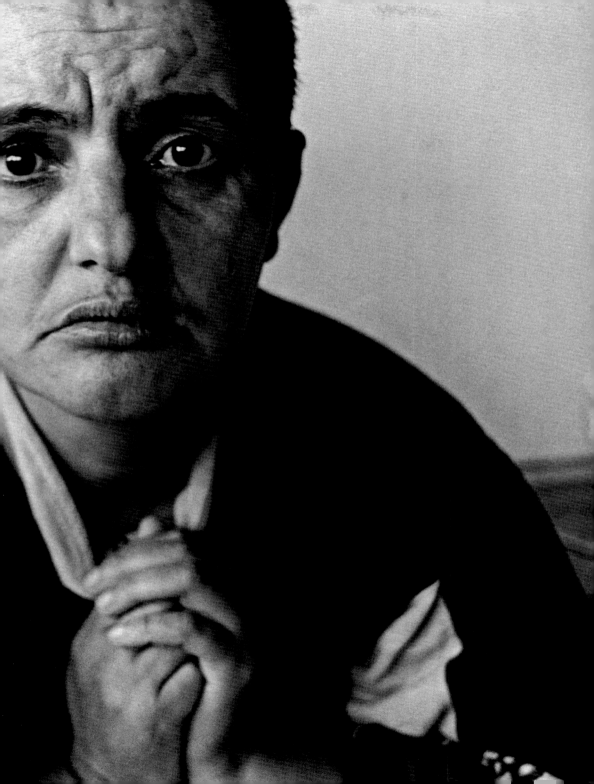

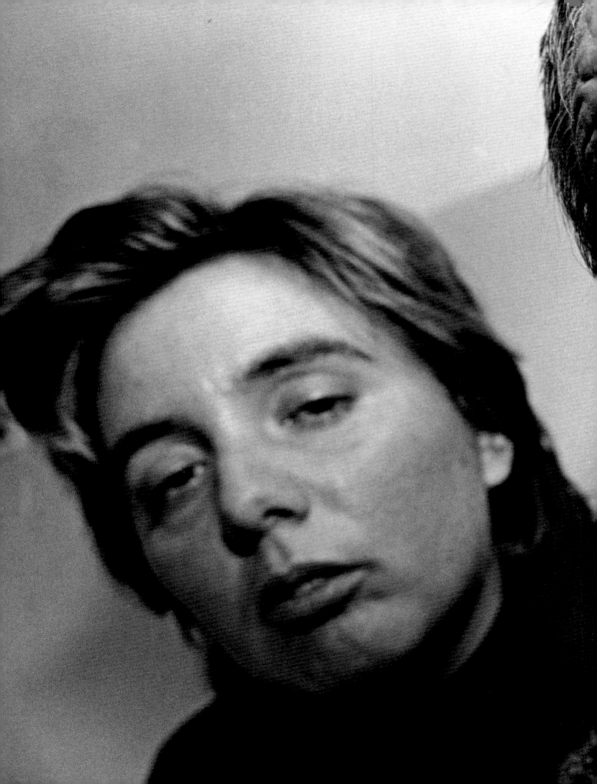

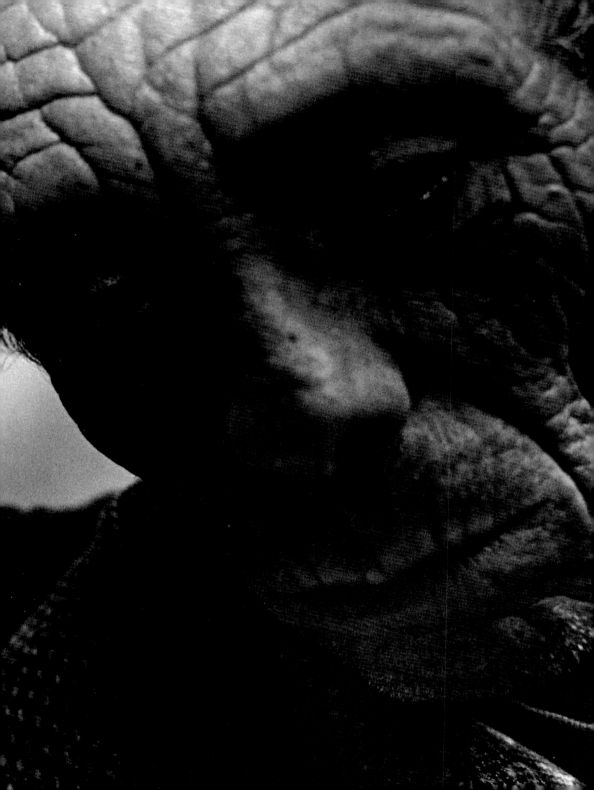

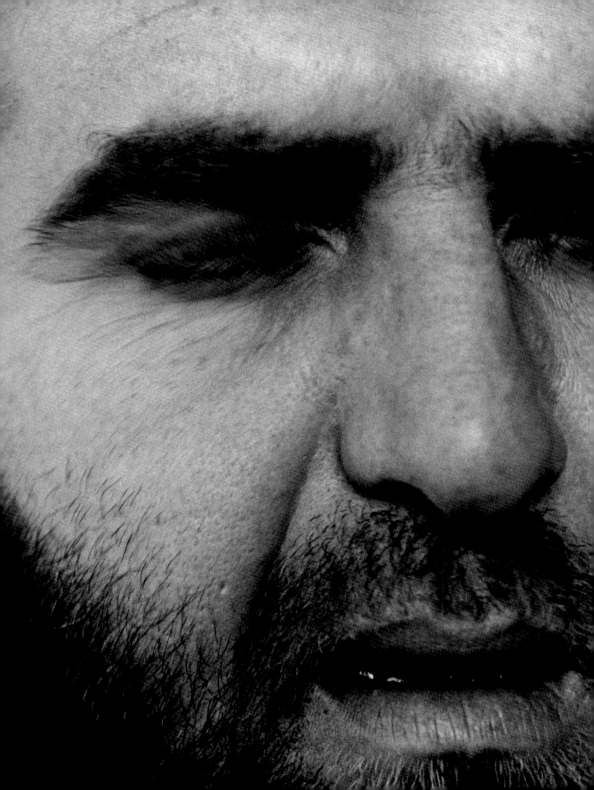

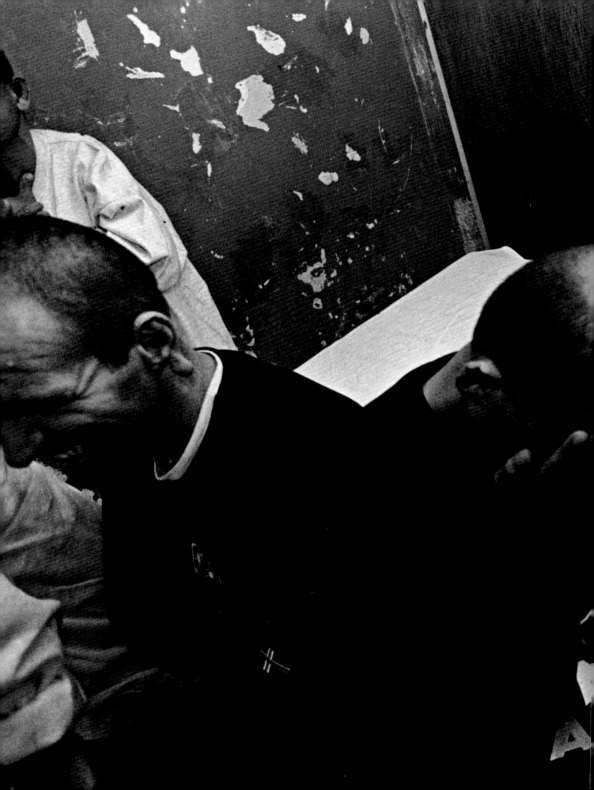

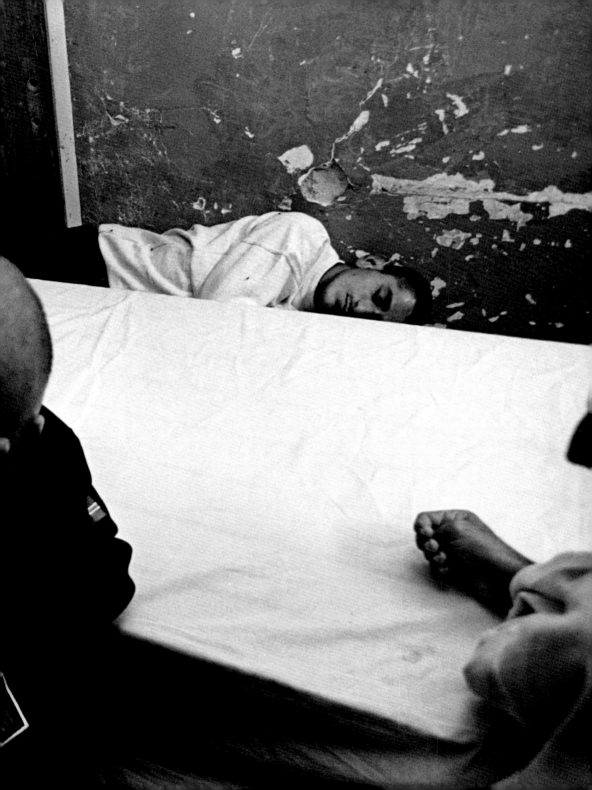

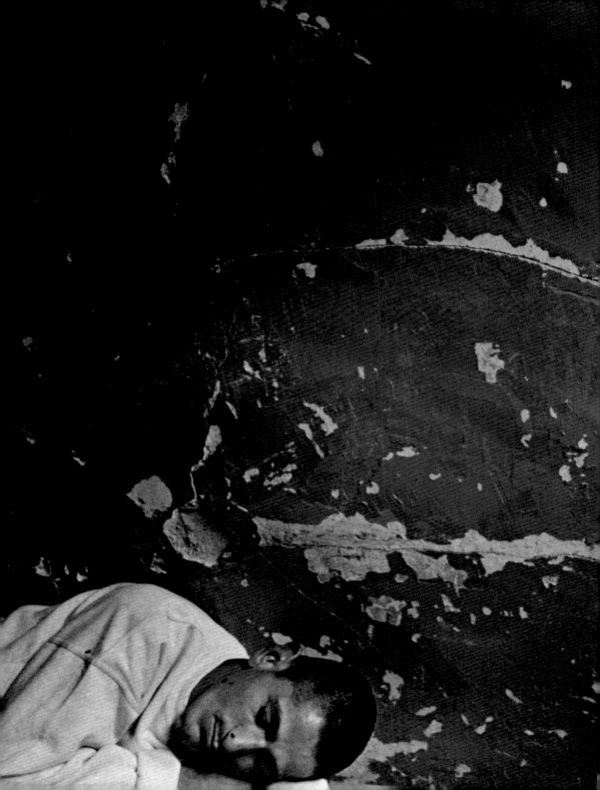

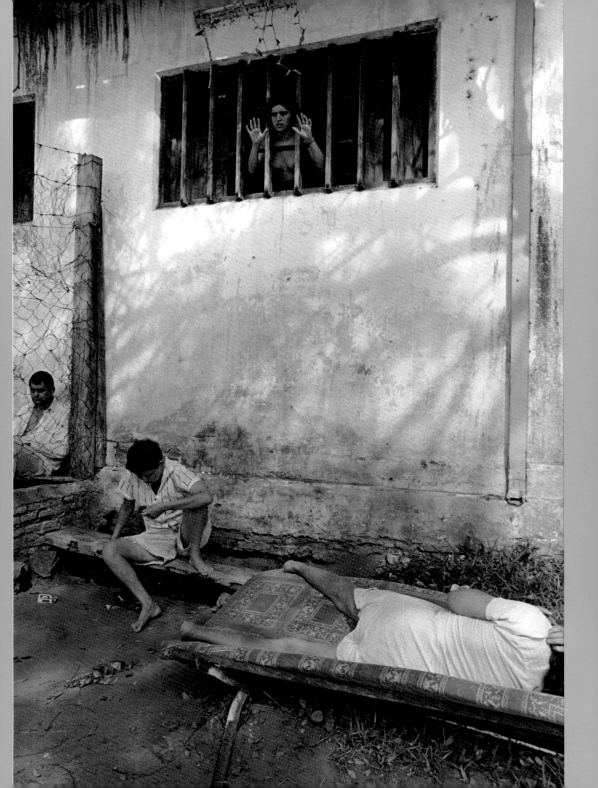

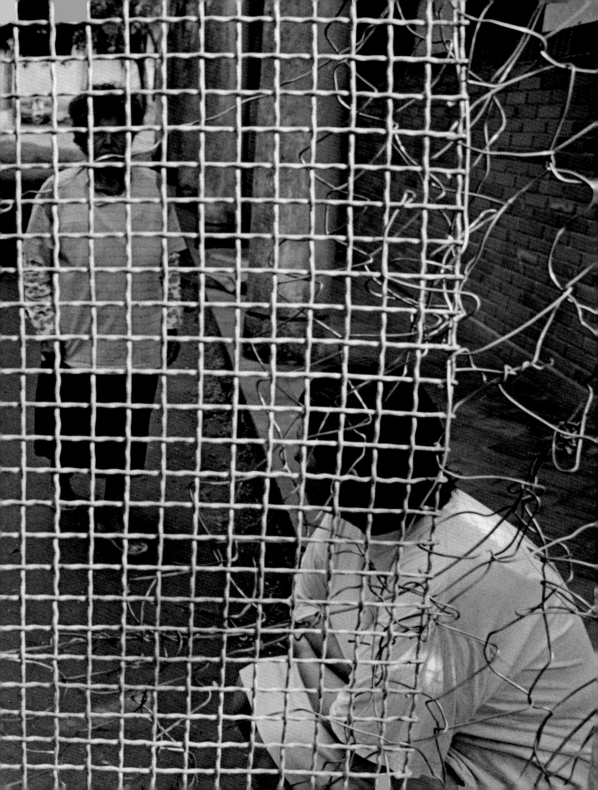

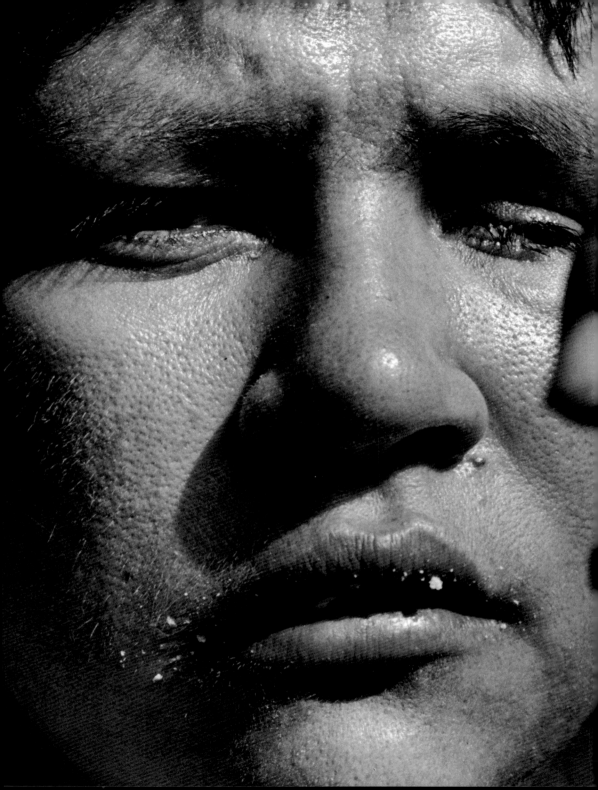

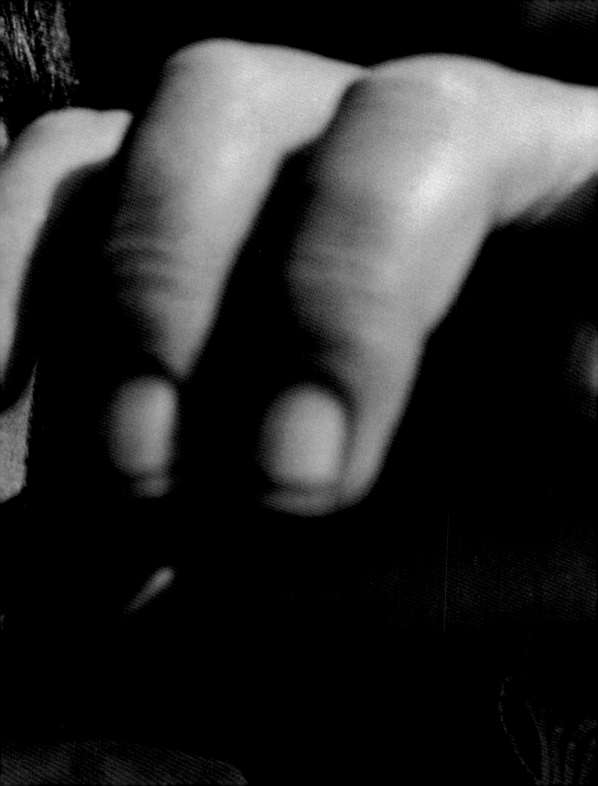

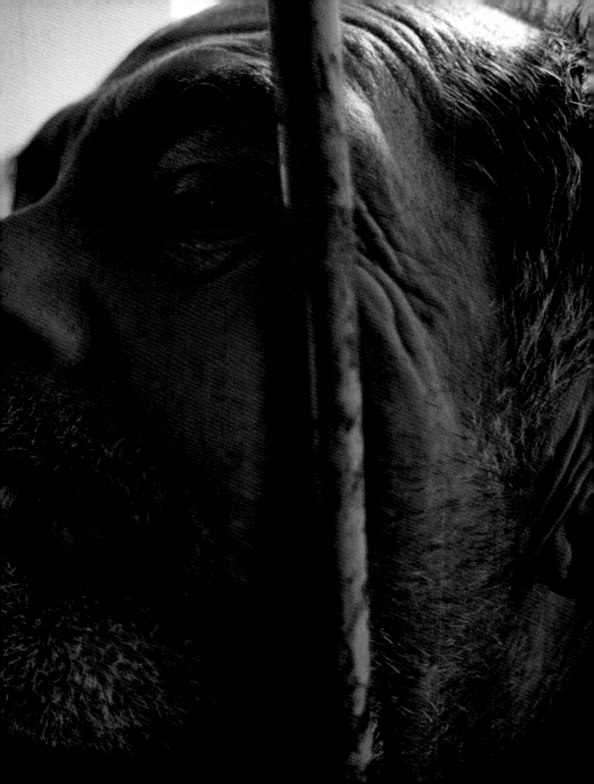

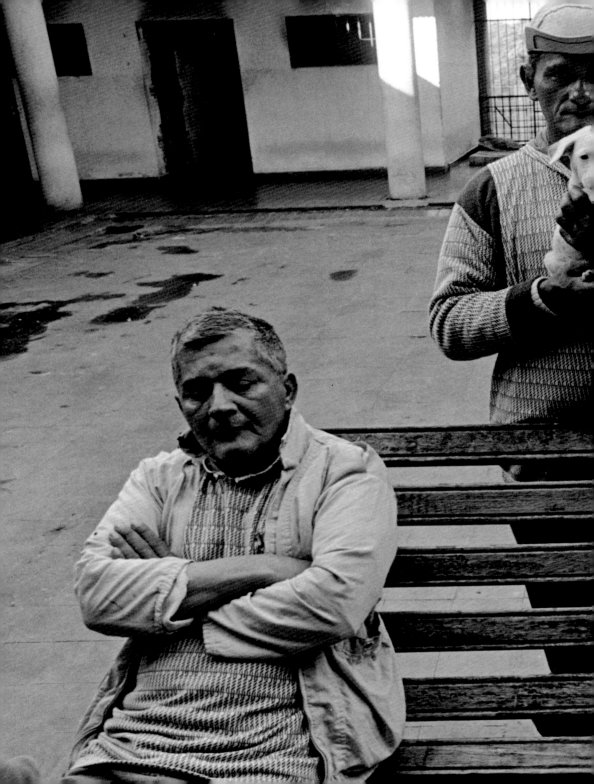

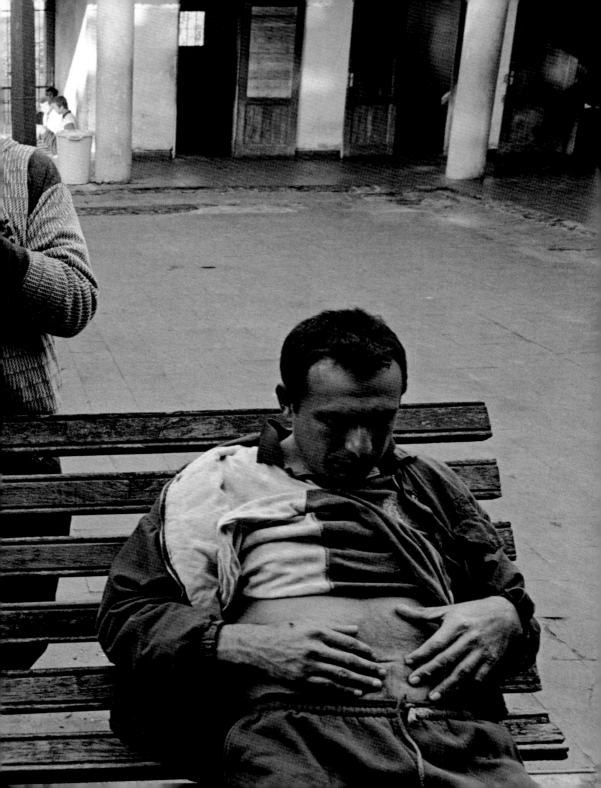

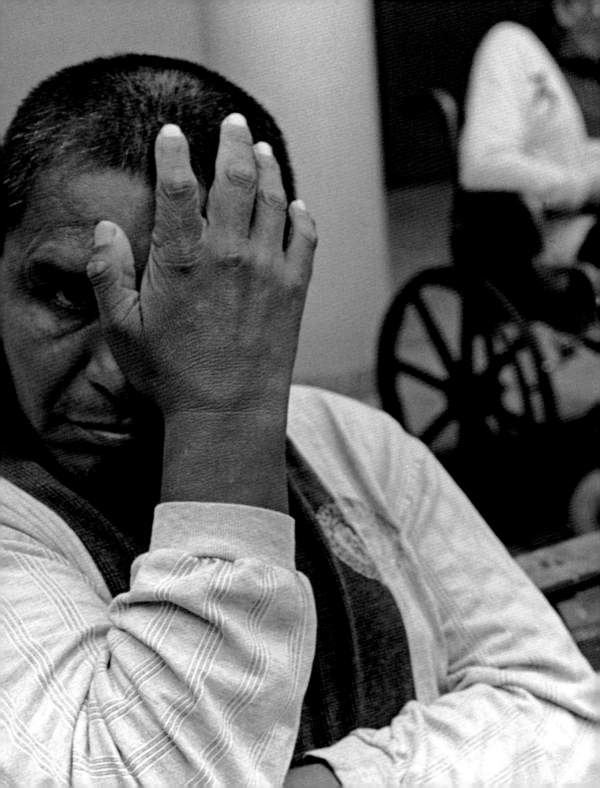

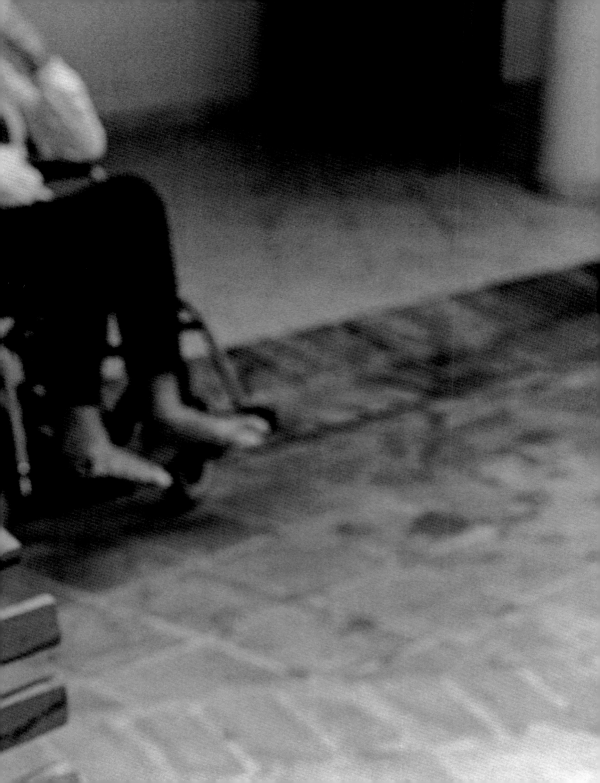

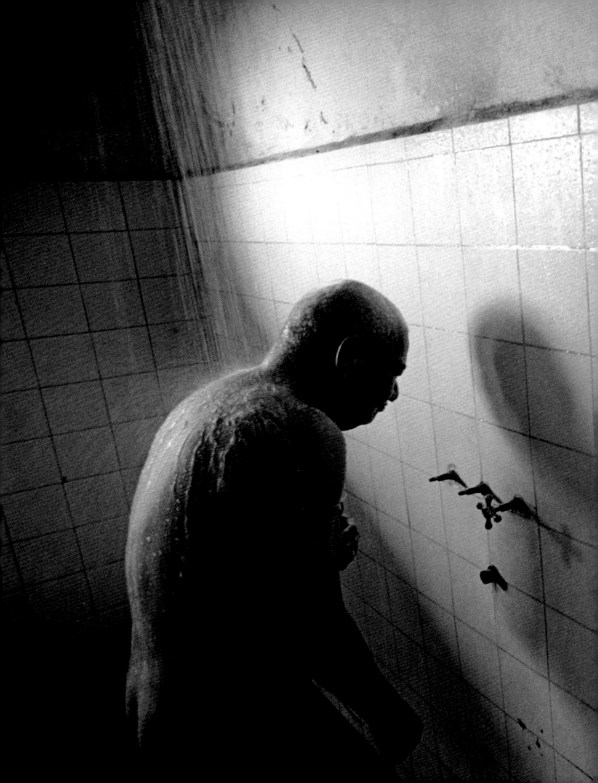

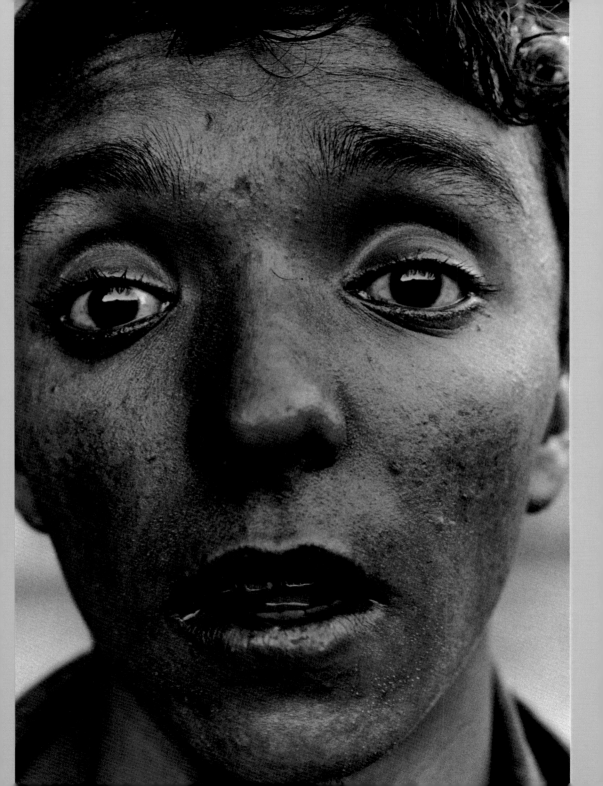

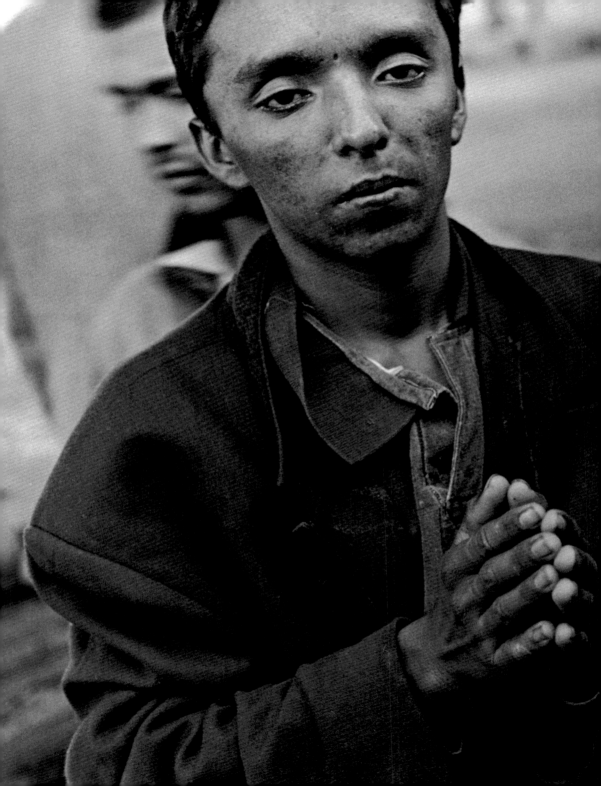

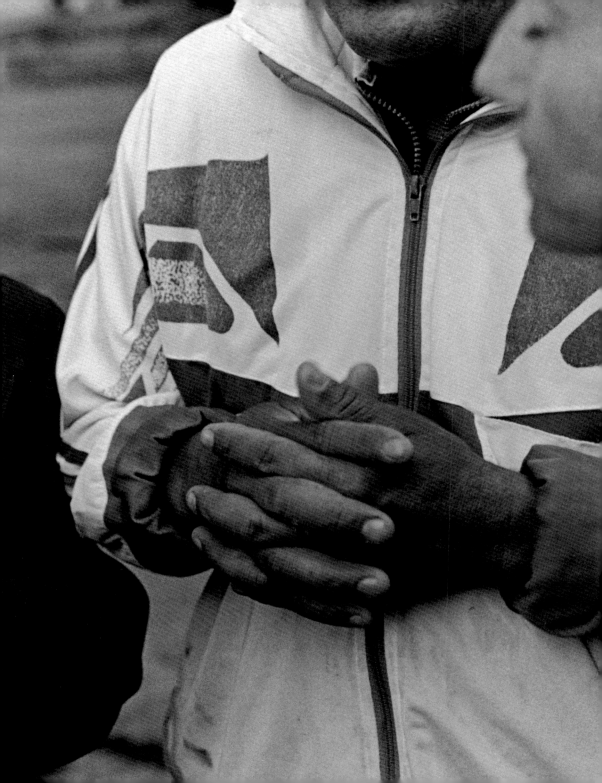

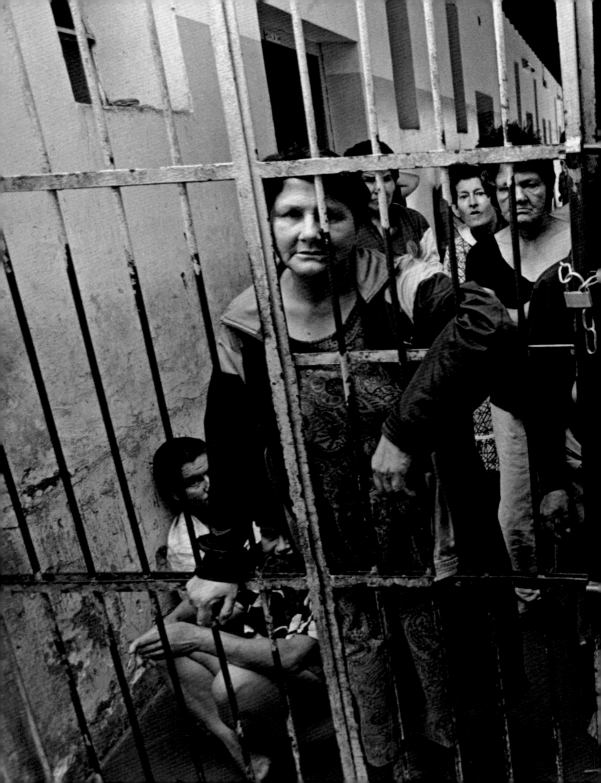

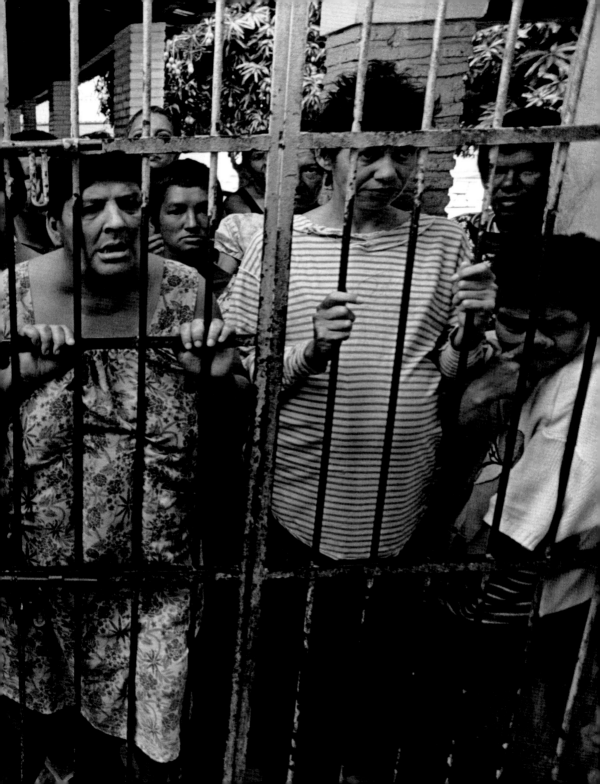

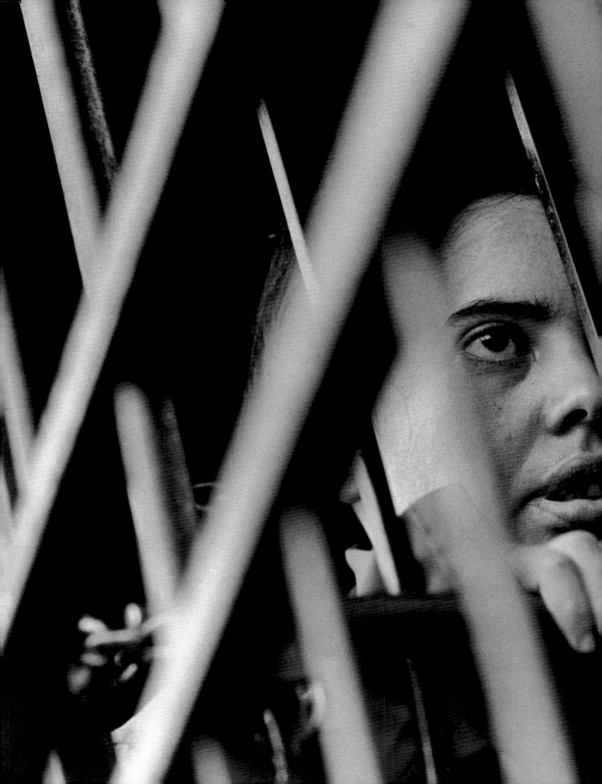

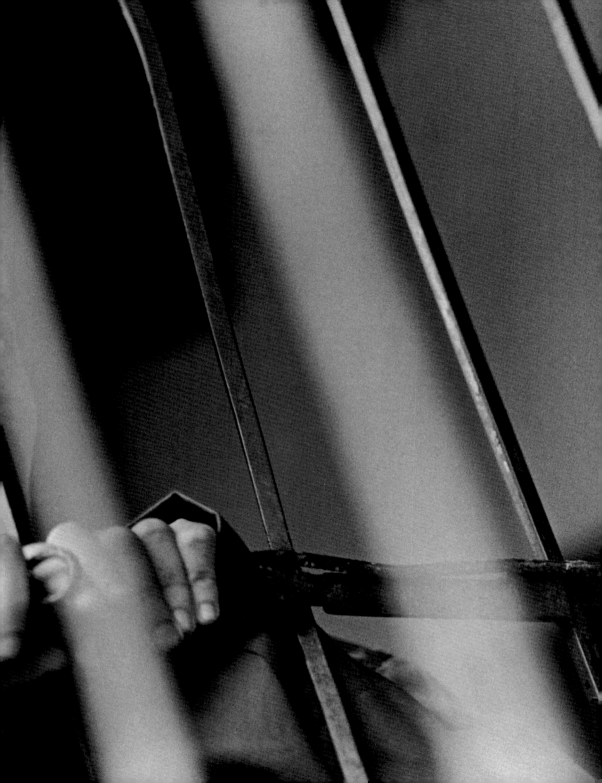

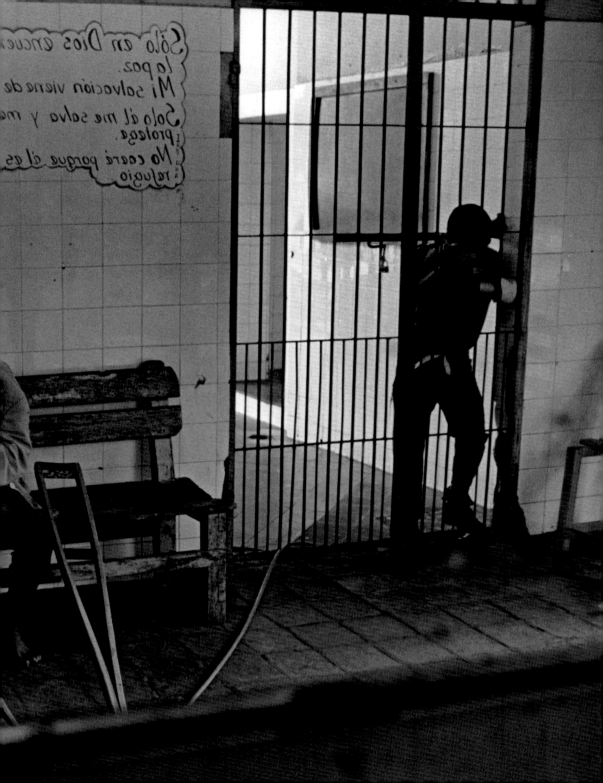

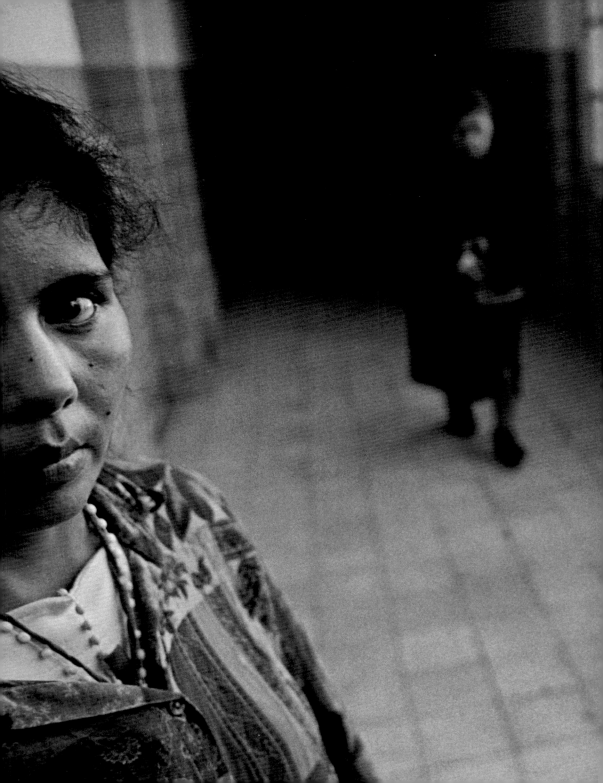

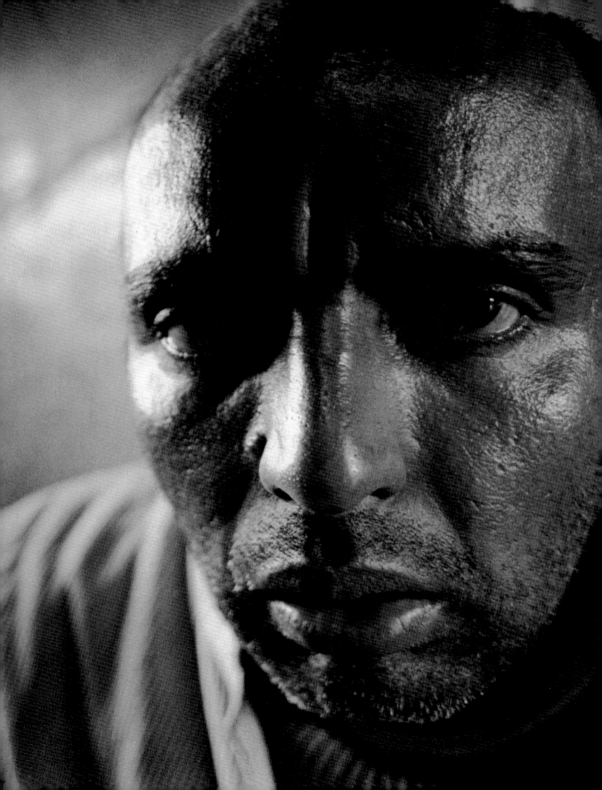

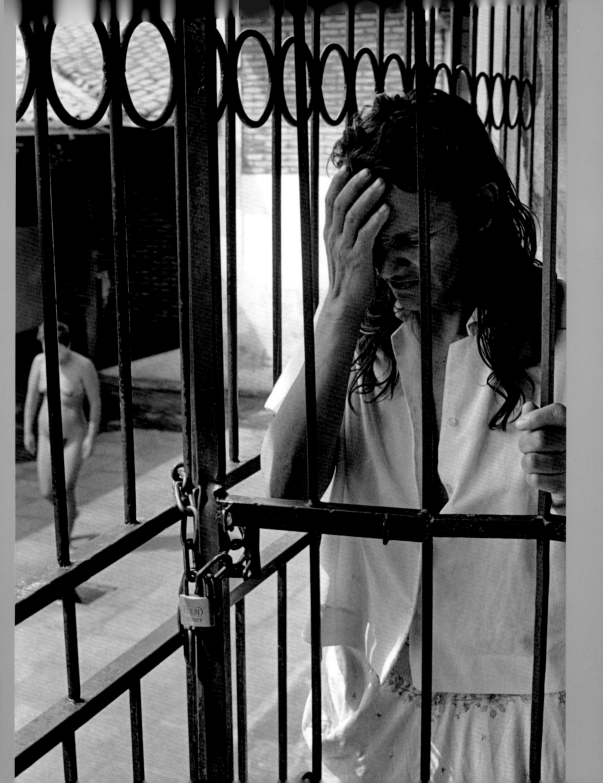

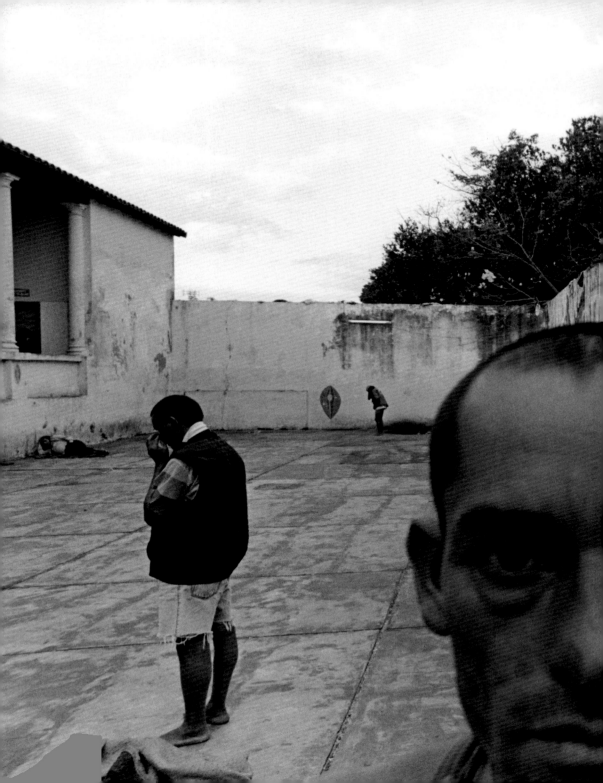

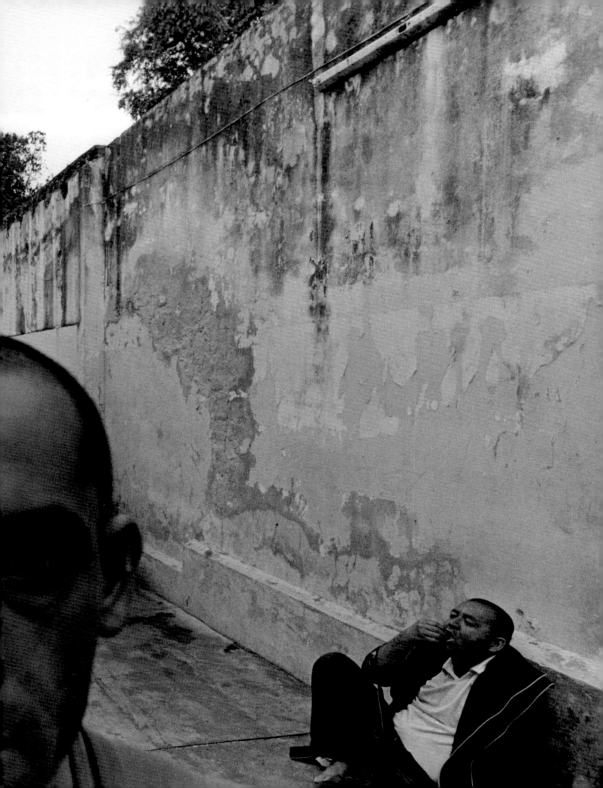

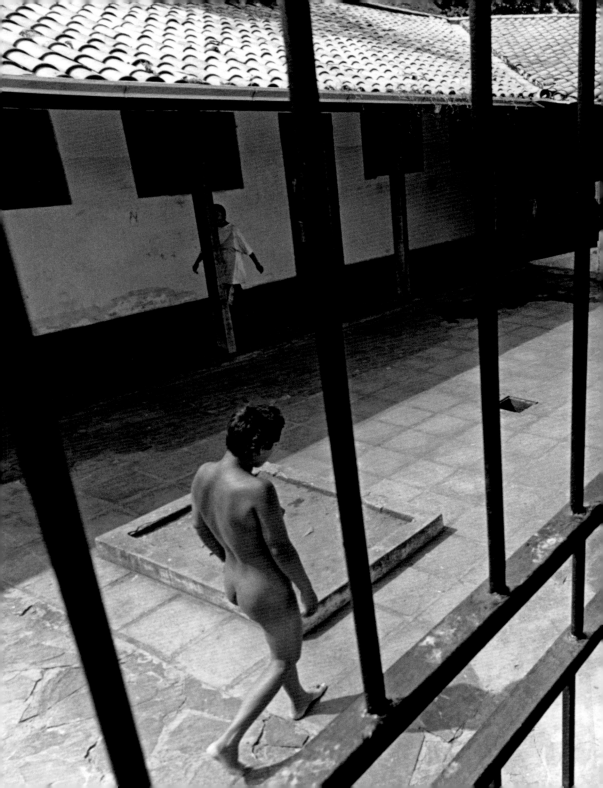

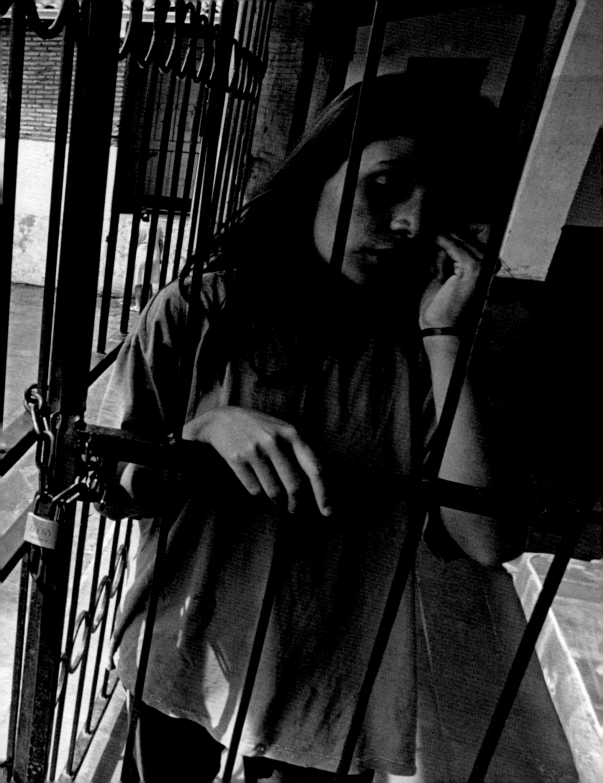

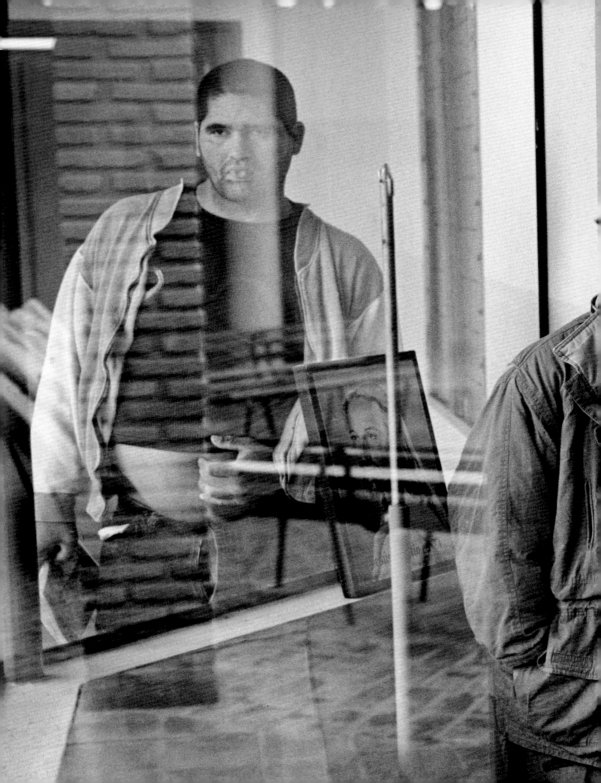

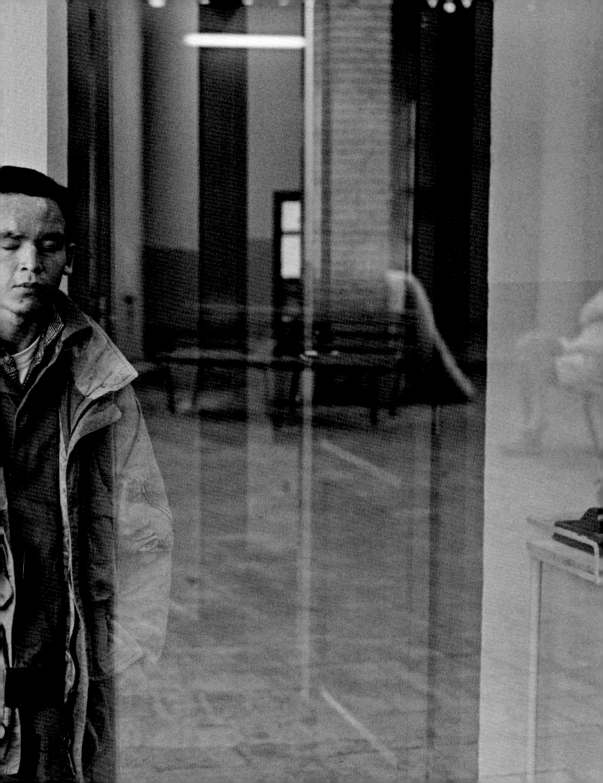

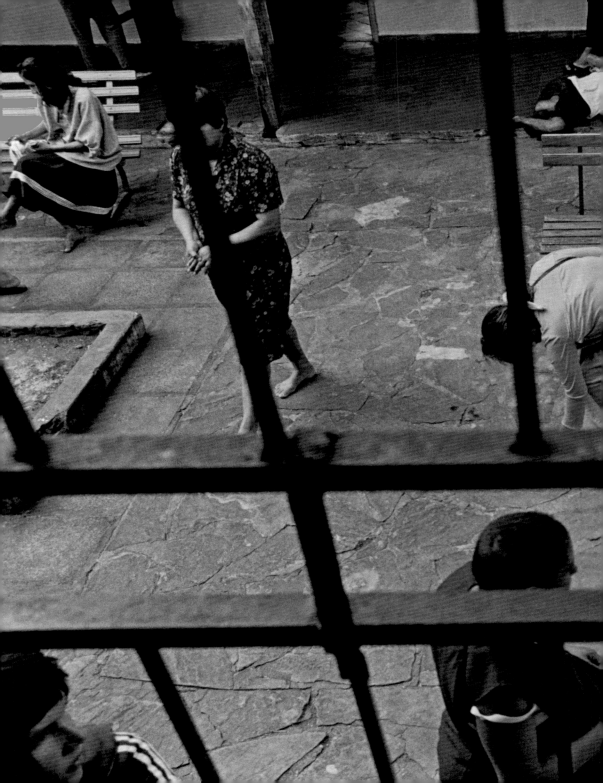

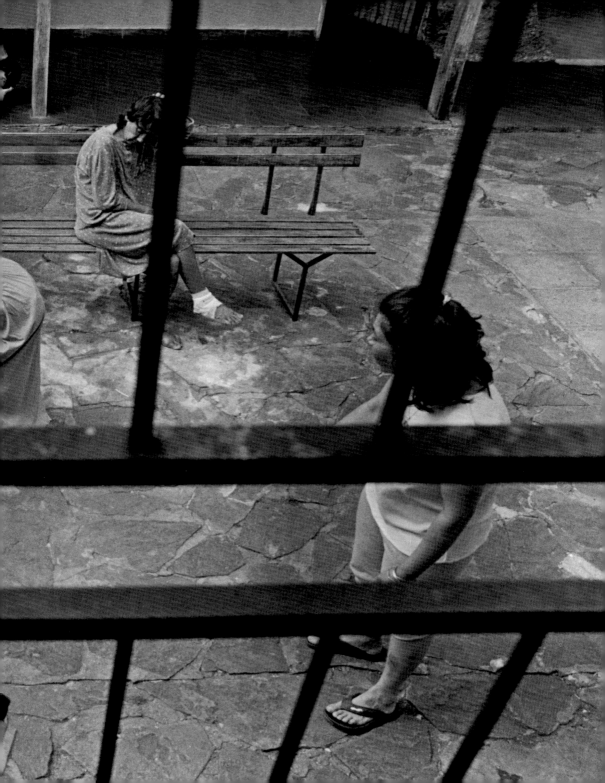

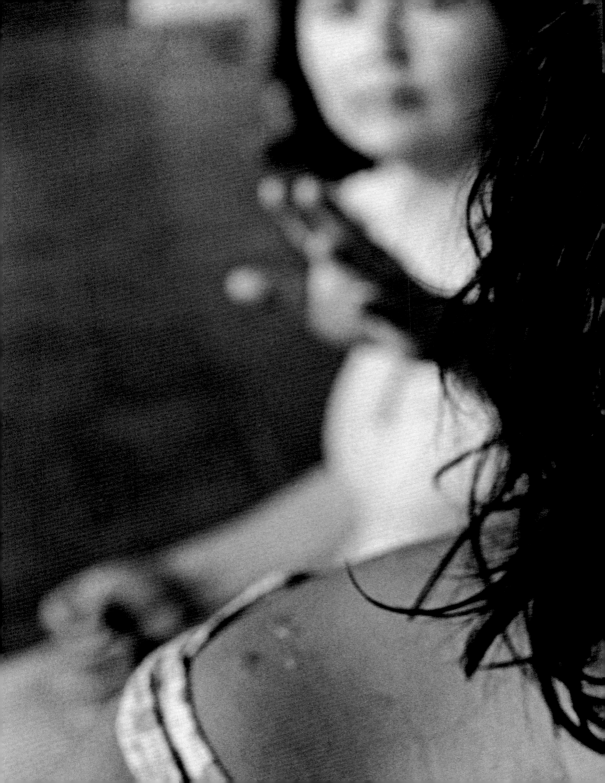

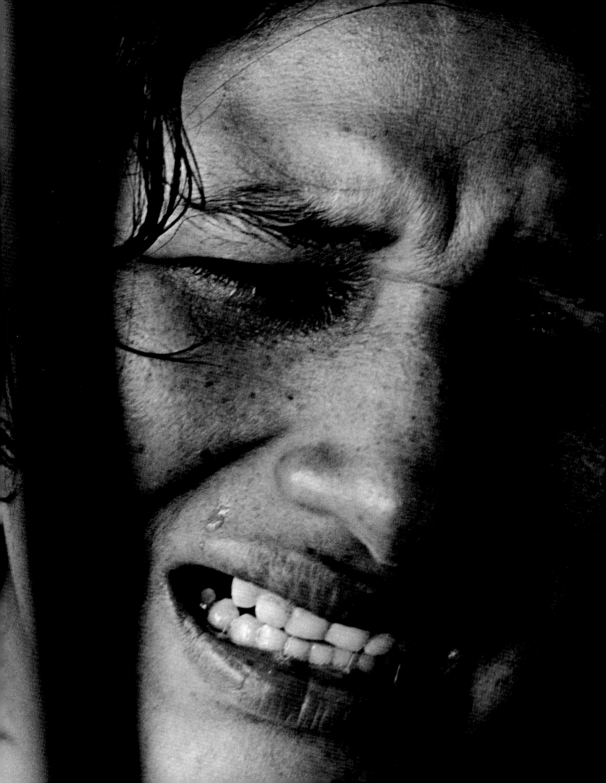

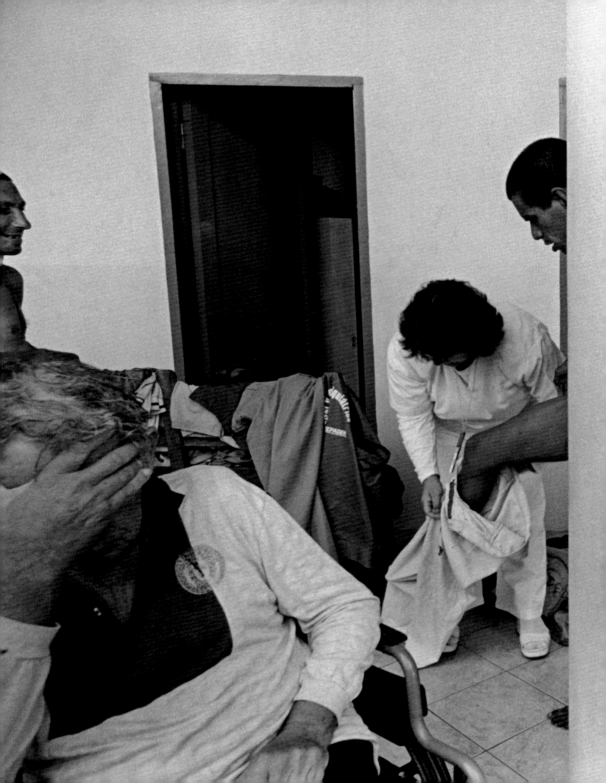

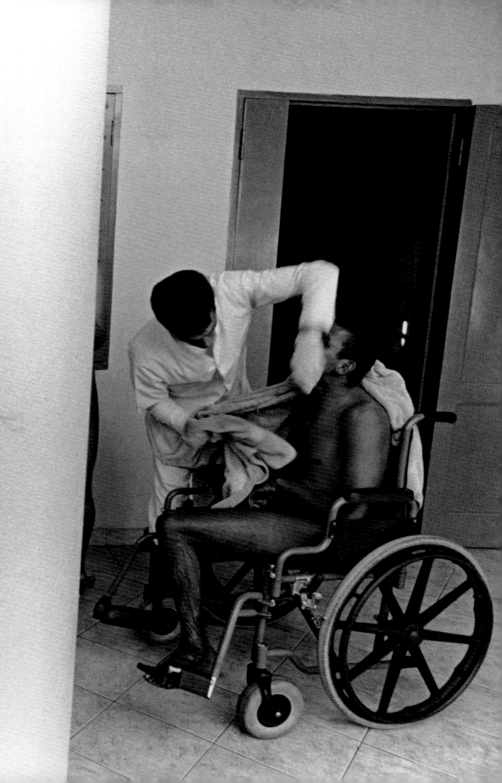

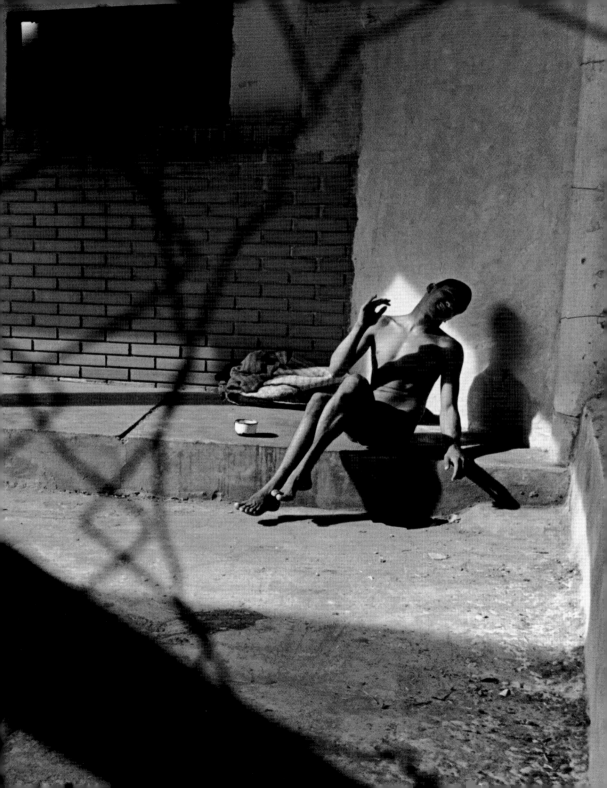

"I have been here ten years, but I don't know why I am here."

Hidalgo, Mexico. Everyone in the van stopped talking and held their breath. The gate at the end of the road leading to the psychiatric hospital was open, the guard shack empty. It was still dark, so all we could see of the person who let us in were his hands.

"Hurry, hurry." There were ten people sneaking into Ocaranza that fall morning—human rights lawyers, a medical doctor, a psychiatrist, social workers, and the activists from Mexico City who brought us there. The group split up. Three of us rushed through an archway down a gloomy hallway toward the men's ward, where the attendant, talked into believing that ours was an official tour, unlocked the door.

The first room was full of cots, more than a hundred of them, lined up in rows, inches apart, each covered with a lumpy, sagging mattress and a worn blanket. There were no bureaus, shelves, or items of clothing, not even a T-shirt or a sock. No family pictures, crucifixes, nameplates—nothing to distinguish one patient from another. Further along the corridor was a stinking, overflowing bathroom which had no toilet seats, no doors on the stalls, no toilet paper.

The corridor ran like a lonely, dismal, fluorescent-lit stream through the institution, then opened up into a vast, garage-like space. All that separated me now from the patients was a low wall. Clambering over it, I so startled a man that he stood poised and frozen in mid-step. For a few moments we stood looking at each other, a great chasm between us, me on one side, warm in my winter coat, free to go, and him on the other.

It was close to eight. The sun was beginning to filter in through the barred windows, but it was still cold inside, no more than forty-five degrees. A television glowed high up on a wall. In the middle of the floor was a puddle of urine that ran half the length of the ward. A man was crawling past; the stream was slowly spreading, collecting on the down-sloping cement. Around the edges of the room were clumps of men—two, three, four of them—pressed against one another under a single blanket. The patients who weren't huddled together for warmth were walking, shuffling, stumbling up and back—a procession of them.

"I don't have anything. I don't have a comb, a toothbrush, clothes.
I don't have socks. No one has."

Guadalajara, Mexico. Trying to see through the barred windows into the children's ward at Jalisco was like peering into a brackish pond in the middle of the night. Faces would float by, half-hidden by the scratches and handprints on the surface of the glass.

If the attendant who opened the door was annoyed by our visit, she didn't immediately show it; what you have here, you could imagine her thinking, is the way it has always been, always will be. There were no toys or playthings for the children; no decorations of any kind on the high, bare concrete walls; and no treatment programs, unless you consider the use of physical restraints on the ones who habitually hurt themselves a treatment program. We heard sobbing, then thumping sounds. A boy who had fallen from his bed began banging his head on the floor. There was a girl who was thirteen or fourteen lying half-clothed on a bed soiled with feces and urine. Across from her a ten-year-old boy was tethered by the stump of his leg to the bars of the window above him.

> *"I have been here for a year and seven months because I pushed my grandmother and stabbed a dog with a knife. Now I sleep on the same bed as Carlos because it is cold. And I sleep outside because it is safer outside. Pills, I take two pills a night. I sleep well. I dream that I am riding my bicycle very fast."*

Kapan, Armenia. There were a half-dozen patients standing at the very back of what could only be called a cell: under a bare lightbulb, not moving, barely breathing, staring out. The attendant told us that the medical director wouldn't be returning for hours, perhaps thinking we would leave. Then he went on to explain that all that separated the patients in the Psychiatric Dispensary from those in the adjoining tuberculosis hospital was the iron gate.

When he returned, the medical director wasn't pleased that we had come there without an appointment. This could cause him some difficulties with local officials, he said. But rather than order us out, the doctor took us aside and explained that the dispensary was the only psychiatric facility for hundreds of miles around, that it was overcrowded because he wouldn't turn anyone away, and that it was run-down because there was not enough money even for patient care. Then, because we had traveled such a very long distance, he directed the attendant to open the gate and let us in.

"My family abandoned me here eight years ago when my mother died. There's an old woman who's been here about forty years. She's about ninety. There are at least ten women who've been in this ward for years. They are left over from the past."

Asunción, Paraguay. The first stop was at a private group home a mile from the state psychiatric hospital. A thirteen-year-old boy was being held in a cage barely big enough for an average-sized dog. Having had epilepsy since birth, the boy was on sedatives and anti-seizure drugs, so many that he constantly drooled. There were socks fastened on his hands, preventing him from sucking on his fingers that had been burned in a fire.

"The first time I came here was because I was very depressed. My sister wanted to take my two daughters from me. I went to the psychiatrist and he asked me why I had been hit on my face. I told him that my husband did it. So the doctor said it is a familiar problem. And he gave me some medicine. Then I came in here. My husband says that I am insane. I have some scars on my forehead and a scar on my nose. He punched me."

Asunción, Paraguay. It was just past noon when the group from Mental Disability Rights International pulled into the Neuro-Psychiatric Institute and set to work. Rumor was there were two teenage boys being warehoused somewhere inside the dank, decaying facility, that they had been there for years. After MDRI managed somehow to gain entrance, I followed one of their care workers onto a locked ward, through a courtyard crowded with patients, then along a dark corridor where we happened upon the boy we would come to know as Jorge. He was crouched down in a padlocked cell, naked, his face half-hidden by the thick iron bars. When Alison and I moved closer, Jorge reached for our hands, throats, faces. He grasped my hand, but the seventeen-year-old was so strong I had to pull away. It was then that he began to laugh uncontrollably. We found Julio in another cell twenty feet further on.

Abandoned by their families, Julio and Jorge had been held for four years in these six-by-nine-foot enclosures that had holes in the floor for toilets, no electricity, and openings in the barred doors through which their food was passed.

"What is your name?"
"Victor."
"How old are you, Victor?"
"Fifty-nine years old."
"How long have you been here?"
"Thirty-eight years."
"Why did you come here?"
"I don't know."

Pristina, Kosovo. Shtime is a sprawling firetrap of a psychiatric hospital in a war-troubled country. We went there very early on an overcast September morning. While the activists from MDRI were questioning the administrators and staff about their use of electroshock treatments, four-way restraints, and psychotropic drugs, I was ducking into the wards, photographing patients who were crawling, weeping, walking aimlessly about, lying together in heaps. I listened as a group of female patients spoke in hushed voices of having been raped inside the institution. One woman said she was raped after attendants locked her in a room with a male patient in order to "calm her down."

"I don't like it here. It feels like a prison that kills. It's a prison that chases us day by day, and kills us by injecting us with medication."

Asunción, Paraguay. There was never enough time. If we kept moving and didn't wholly alienate the staff, it was possible to stay in an institution two, maybe three hours. But then, almost always without warning, our group would be asked to leave. Making our way outside, we would slump exhausted into the van. No one would want to talk. Someone might call out, "Everyone okay?" But that was about it.

Back in my hotel room I would turn on the TV, try to read, to sleep, but I could still hear the muffled cries, smell the urine and the sweat, see the exhausted-looking patients staring out through the bars. I would try to remind myself that there have been changes, that progress is being made. Still, there is no way around it; no one much cares. The kinds of cruelty and suffering we had witnessed here, we had also witnessed in Kosovo, Hungary, Argentina, Armenia, and Mexico—as if there is a kind of worldwide agreement that once people are classified as mentally ill or mentally retarded, you are free to do to them what you want.

pages 2–3, 4–5 Kapan, Armenia. Iron gate that separates the Psychiatric Dispensary from the adjoining tuberculosis unit. / pp. 6–7 Kapan, Armenia. The only psychiatric facility for hundreds of miles. / pp. 10–11 Hidalgo, Mexico. A stream of urine runs through the men's ward at the Ocaranza Psychiatric Hospital. / pp. 12–13 Hidalgo, Mexico. One hundred and ten men are held in a ward with only one attendant. / pp. 14–15 Hidalgo, Mexico. A patient thrown to the floor by another patient. / pp. 17, 18 Hidalgo, Mexico. An elderly woman who may have Alzheimer's disease sits shivering in the women's ward at Ocaranza. / pp. 20–21 Hidalgo, Mexico. Above the men's ward hangs a silent, unwatched television. / pp. 22–23 Hidalgo, Mexico. A patient hides to avoid being herded to the showers. / pp. 24–25 Hidalgo, Mexico. Being bathed against his will. / pp. 26–27, 28–29 It is 48 degrees Fahrenheit, the water is icy cold, and there are no towels for the patients. / pp. 30–31, 32–33 Hidalgo, Mexico. Having been abandoned at birth, a seventeen-year-old girl is momentarily freed from the straitjacket she is confined in twenty hours a day. / p. 35 Hidalgo, Mexico. The courtyard of Ocaranza. / pp. 36–37 Guadalajara, Mexico. A young patient at the Jalisco Psychiatric Hospital. / pp. 38–39 Guadalajara, Mexico. In the children's ward at Jalisco, a boy without feet tethered to a barred window. / pp. 40–41 Guadalajara, Mexico. Children at Jalisco housed with adults. / pp. 42–43 Hidalgo, Mexico. Wheelchair-bound patients at Ocaranza. / pp. 44–45 Hidalgo, Mexico. An elderly woman cradles the doll that she carries everywhere. / p. 47 Guadalajara, Mexico. A newly committed patient at Jalisco is put in restraints. / pp. 48–49 Guadalajara, Mexico. A teenage boy in the children's ward at Jalisco. / pp. 50–51 Guadalajara, Mexico. After resisting being brought to Jalisco, a patient is tied to a bed. / pp. 52–53 Mexico City, Mexico. Patient at the Casa de Protección. / pp. 54–55 Mexico City, Mexico. A patient, whose single uttered word is "Adiós," clasps his head in pain. / p. 57 Asunción, Paraguay. Portrait resembling Jesus scratched onto a wall at the Neuro-Psychiatric Hospital by a patient whom others fear. / pp. 58–59 Asunción, Paraguay. Built as a paupers' home, the hospital now holds 460 patients. / pp. 60–61 Asunción, Paraguay. Screaming and pulling at the bars, this woman has repeatedly tried to escape. / pp. 62–63 Asunción, Paraguay. Seventeen-year-old Julio has been held four years in a tiny, unlit cell. / p. 65 Asunción, Paraguay. Seventeen-year-old Jorge, who has autism, peers out of his locked cell. / pp. 66–67 Asunción, Paraguay. After reaching out for people, Jorge grows silent when they leave. / pp. 68–69 Asunción, Paraguay. Patients crowd against the gate. / pp. 70–71 Asunción, Paraguay. The forty-six residents of Sala 2 pull their mattresses into the courtyard so that their sleeping rooms can be hosed down. / pp. 72–73 Asunción, Paraguay. Mealtimes are crowded, noisy. / pp. 74–75 On some wards, the chronically ill live side-by-side with patients who have just arrived. / pp. 76–77 Asunción, Paraguay. A patient treats a younger patient as a daughter she must care for. / pp. 78–79 Asunción, Paraguay. While most patients live solitary lives, a few form relationships. / pp. 80–81 Asunción, Paraguay. Patients gather in one of the outdoor enclosures. / p. 83 Buenos

Aires, Argentina. The thousand-bed Moyano Psychiatric Hospital. / pp. 84–85 Pristina, Kosovo. A patient in the Special Center at Shtime, where women were reportedly sexually abused. / pp. 86–87 Pristina, Kosovo. Patients' washed clothes outside a ward. / pp. 88–89, 90–91 Budapest, Hungary. A young boy lives and plays in a locked ward of a state hospital with his emotionally troubled mother. / pp. 92–93 Budapest, Hungary. The worst thing about being institutionalized, this patient explains, is the loneliness. / pp. 94–95 Budapest, Hungary. Reportedly, relatively few of the people in the social care homes are mentally ill. / pp. 96–97 Yerevan, Armenia. A former frontline soldier who hears voices has been diagnosed as schizophrenic by some doctors, and deemed cowardly by others. / pp. 98–99, 100–101 Pristina, Kosovo. With few treatment programs, patients at Shtime spend days alone in the barren rooms or lying on the pavement. / p. 103 Asunción, Paraguay. Said to have been addicted to drugs, a patient peers out a window at the Neuro-Psychiatric Hospital. / pp. 104–105 Asunción, Paraguay. Two of more than two hundred women at the hospital. / pp. 106–107 Asunción, Paraguay. A woman whose left eye was gouged out by another patient who was permitted to remain on the ward. / pp. 108–109 Asunción, Paraguay. Despite staff denials that this had occurred, this man spent four days in solitary confinement. / pp. 110–111 Asunción, Paraguay. A longtime patient hopes to adopt a stray puppy. / pp. 112–113 With few, if any, treatment programs, patients sit idly in the open courtyard. / pp. 114–115 Asunción, Paraguay. An elderly patient from the chronic ward. / p. 117 Asunción, Paraguay. This shy, frail, eighteen-year-old is preyed upon by other patients. / pp. 118–119 Asunción, Paraguay. Unable to defend himself against aggressive patients, he talks to God. / pp. 120–121 Asunción, Paraguay. Gateway into the women's chronic ward at the Neuro-Psychiatric Hospital. / pp. 122–123 Asunción, Paraguay. Patients considered "difficult" are held in small locked cells above the courtyard. / pp. 124–125 Asunción, Paraguay. A patient who is free to wander the hospital grounds. / pp. 126–127 Asunción, Paraguay. Patients in a clinic corridor. / pp. 128–129 Asunción, Paraguay. A patient who once worked as a tailor sits in his room, wondering how he came to be in this place. / p. 131 Asunción, Paraguay. A woman is locked in a cell, while others pace back and forth. / pp. 132–133 Asunción, Paraguay. The oldest, most run-down of the wards houses the chronically ill. / pp. 134–135 Asunción, Paraguay. There are forty women confined in this hospital pavilion. / pp. 136–137 Asunción, Paraguay. A patient who grew up in an orphanage and now suffers epileptic seizures. / pp. 138–139 Asunción, Paraguay. Among the patients in the acute ward is a woman who murdered her husband, and another who plucked out a patient's eye. / pp. 140–141 Asunción, Paraguay. There are patients who attempt to lock themselves up in order to be alone. / pp. 142–143 Asunción, Paraguay. Despite limited resources, some attendants do their best to care for patients. / pp. 144–145 Asunción, Paraguay. After being held most of the day in a tiny cell, Jorge is allotted time in a bare, but sunny, space.

Acknowledgments

I wish to thank Eric Rosenthal, Alison Hillman de Velasquez, Laurie Ahern, Brittany Benowitz, Dr. Robert Okin, and all those associated with MDRI for inspiring and encouraging this body of work; Kathy Ryan of the *New York Times Magazine* and Melissa Harris of *Aperture* for supporting stories on the plight of the mentally disabled; and Brian Young, Juan Arredondo, Erica Murray, and Sam Richards for their friendship and assistance.

Deepest gratitude to Theresa May, Ellen McKie, and the staff of the University of Texas Press for graciously publishing this book; to Dave Hamrick of UT Press for his guidance and enthusiasm; and to Janine Altongy, who conducted patient interviews and in all ways assisted in the creation of this work.

The production of *A Procession of Them*, and of the short film of the same name, was funded in part by a grant from the Joseph P. Kennedy, Jr. Foundation, a Rosalynn Carter Fellowship for Mental Health Journalism, and a grant from U.S. Programs of the Open Society Institute.

Mental Disability Rights International

Mental Disability Rights International (MDRI) is a global advocacy organization dedicated to the human rights and full participation in society of people with disabilities. Founded in Washington, D.C., in 1993 by Eric Rosenthal, MDRI has conducted human rights investigations in twenty-four countries and has, to date, published reports on the often inhumane and degrading conditions within psychiatric institutions in Uruguay, Hungary, Russia, Mexico, Kosovo, Peru, Turkey, Romania, Argentina, and Serbia. Drawing upon the skills and experience of attorneys, mental health professionals, human rights advocates, and people with mental disabilities and their families, MDRI trains and supports advocates seeking legal and service system reforms and assists governments in developing laws and policies to promote community integration and human rights enforcement for people with mental disabilities.

∞ The paper used in this book meets the minimum requirements of ANSI/NISO Z39.48-1992 (R1997) (Permanence of Paper).

Library of Congress Cataloging-in-Publication Data

Richards, Eugene.
 A procession of them / Eugene Richards. — 1st ed.
 p. cm. — (The William and Bettye Nowlin series in art, history, and culture of the Western hemisphere)
 ISBN 978-0-292-71910-1 (cloth : alk. paper)
 1. Psychiatric hospital patients—Portraits. 2. Portrait photography. 3. Documentary photography.
 4. Richards, Eugene. I. Title.
 TR681.P76R53 2008
 779'.936221—dc22 2008017177

The William and Bettye Nowlin Series in Art, History, and Culture of the Western Hemisphere